Rare Books

Rare Books
STEPHEN H. VAN DYK

Scala Publishers
In association with
Cooper-Hewitt, National Design Museum
and Smithsonian Institution Libraries
Smithsonian Institution

Smithsonian
Cooper-Hewitt, National Design Museum

Smithsonian Institution Libraries

First published in 2001 by
Scala Publishers Ltd
Fourth Floor
Gloucester Mansions
140a Shaftesbury Avenue
London
WC2H 8HD

In association with
Cooper-Hewitt, National Design Museum
Smithsonian Institution
2 East 91st Street
New York, NY 10128-0669

and Smithsonian Institution Libraries
10th and Constitution Ave., NW
Washington, D.C. 20560-0154

ISBN 1 85759 238 7

Library of Congress Cataloging-in-Publication Data

Van Dyk, Stephen H.
 Rare books / Stephen H. Van Dyk.
 p. cm.
Includes bibliographical references.
 ISBN 1-85759-238-7
 1. Smithsonian Institution. Libraries. Cooper-Hewitt, National
Design Museum Branch. 2. Rare books—New York (State)—New
York. 3. Libraries—New York (State)—New York--Special collec-
tions—Design. 4. Libraries—New York (State)--New York—
Special collections—Decorative arts. 5. Book design—History.
6. Illustration of books. I. Title.
 Z733.S67 V36 2001
 026'.09'097471—dc21
 00-011687

This publication has been made possible in part by the Andrew
W. Mellon Foundation Endowment.

Notes Regarding the Illustrations
All books illustrated in this volume, unless otherwise noted, are
part of the collection of Smithsonian Institution Libraries,
Cooper-Hewitt, National Design Museum branch.

Dimensions given in the captions indicate a book's trim size
(width by height).

A Note Regarding Titles
All publication titles referred to in this volume have been tran-
scribed exactly as they appear in the Smithsonian Institution
Research Information System (SIRIS).

Edited by Elizabeth Johnson
Designed by Anikst Design, London
Produced by Scala Publishers Limited
Printed and bound in Italy
Photographs edited by Jill Bloomer
Photographs, except where noted, by Matt Flynn

Half-title page: Figure 96
Title page: Detail of figure 8

Contents

Preface

I am delighted to present *Rare Books* to highlight the rare, unusual, and diverse collections in the Cooper-Hewitt, National Design Museum Library, Smithsonian Institution—one of twenty-two branches of the Smithsonian Institution Libraries (SIL). The branch's collection on design and decorative arts is one of the significant strengths of the SIL's total collection of more than 1.2 million volumes and is used heavily by students of design, the general public, and Smithsonian staff and researchers in New York and Washington, D.C. Records for the entire collection are included in the Smithsonian Library Catalog, which can be searched over the Internet at www.siris.si.edu.

SIL's Cooper-Hewitt Branch Library, also known as the Doris and Henry Dreyfuss Study Center, serves Museum staff, students of the Parsons School of Design master's degree program, and many professionals in the field of design. Its 55,000 volumes and 900 journals (150 current subscriptions) supplement an archive collection containing the papers of distinguished figures in the field of design and the Museum's extensive picture collection. Together, these resources provide a fertile ground for study and illumination, whether the topic is the life of an eighteenth-century designer, authentic period costumes, designs for wallpaper or jewelry, or the history of chairs.

The 100 titles featured in *Rare Books* are only a sampling of the 6,500 rare book volumes and special collections in the Cooper-Hewitt Library. Among them are 700 pop-up and artist's books, as well as seventeenth- and eighteenth-century pattern books chronicling the history of ornament. More than 800 volumes of world's fairs and international exposition literature complement the 2,000 volumes held in other SIL branches. Technical encyclopedias, instruction manuals, guides to painting, glassmaking, enameling, metalwork, architecture and other craft

industries introduce the large collection of manufacturer's trade catalogs at Cooper-Hewitt. Again, these join the 200,000 pieces representing some 35,000 companies that are housed in the Washington, D.C.–based library branches.

Stephen Van Dyk, the Head Librarian at Cooper-Hewitt, has written a lively text that will inform the general reader and design specialist alike. Elisabeth Jakab ably assisted Stephen in this task. A glance at any page only hints at the treasure hoard of images and prints available. Please enjoy browsing and learning about this important Smithsonian collection.

Nancy E. Gwinn, *Director*
Smithsonian Institution Libraries

Introduction

Rare Books examines more than one hundred illustrated printed design books dating from the sixteenth through twentieth centuries in the Library collection of Cooper-Hewitt, National Design Museum, a branch of the Smithsonian Institution Libraries. In addition to standard historical surveys and books with ornamental patterns, a variety of diverse resources traditionally outside the field of design—natural histories, commemoratives, etiquette books, travel guides, sale catalogs, and manuals on materials and techniques—are discussed. Each contributes in some way to an understanding of how objects were designed, manufactured, marketed, and used; taken together, they provide a comprehensive illustrated history of design and the decorative arts.

The Hewitt sisters, who founded the original Museum at Cooper Union (the precursor of Cooper-Hewitt, National Design Museum) in 1897, obtained hundreds of illustrated books—travel accounts, historic surveys, technical manuals, colorful botanicals, and decorative arts and architecture titles—which became the core of the Library's current collection of 6,500 rare books. The Hewitts regularly included books in exhibitions of the Museum's collections of historic textiles, furniture, wallcoverings, ornamental and architectural drawings, tableware, jewelry, ceramics, and other applied arts. They believed, as we do today, that these timeless sources offer an abundant stream of inspiration for students, collectors, and designers.

Book Printing and Marketing

Many printing shops quickly emerged in Europe to produce printed books shortly after Johann Gutenberg (c. 1398–1468) invented moveable metal type in Mainz, Germany, in the 1450s. By 1500, this fledgling industry had produced an estimated nine million volumes—far overshadowing the few

thousand manuscripts created before this time. In the ensuing centuries, printing shops were established in most major European cities, particularly in Venice, Antwerp, London, and Paris. As the demand for and production of books grew in the nineteenth and twentieth centuries, a number of these small printing companies developed into the large publishing houses that produce most of the books today.

Systems for distributing and marketing these early mass-produced books also evolved in the centuries following the invention of printing. In pre-industrial Europe, the production of printed books was expensive and therefore chiefly reserved for a small, wealthy, elite class. Large illustrated volumes were regularly published by subscription—a system whereby a group of rich patrons pledged financial support to a book project in return for each of them receiving a copy of the work for his or her library (along with an acknowledgment in the book itself). Books were also sold and exchanged at auctions and trade fairs. By the nineteenth century, sizable numbers of less expensive titles were being printed to meet the demands of a growing, literate middle class; these were distributed by large publishing houses and sold at commercial book shops, much as they are today.

Illustrations

From 1450 on, a number of technological innovations in the printing process facilitated the greater use of illustrations in books. By the end of the fifteenth century, illustrations were regularly incorporated into printed volumes. For example, the Library's copy of *Liber chronicarium* (1493) (commonly known as the Nuremberg Chronicle), an encyclopedic work about the creation and history of the world, contains more than 1,800 woodcuts (illustrations created from carved wood blocks that were inked, then applied to paper).

By 1540, however, the woodcut had been generally supplanted by the engraving (an illustration created by cutting an image into a metal plate, inking it, then applying it to the printing surface). Engravings were easier to produce, the plates were more durable, and they provided finer detail than woodcuts. Around this time, a limited number of etchings (illustrations derived from a metal plate onto which an image was etched with acid) were also being used in books. Etchings were costlier and took more time to make, but they delivered detailed images that were much closer to the artist's original conception than engravings were. In the centuries to come, book illustrators would continue to use woodcuts, engravings, and etchings in creative new ways, with improved techniques and materials, and in different combinations.

In the seventeenth century a number of new typefaces were introduced and the title page became a regular feature of the book. In the next century, large individual tomes gave way to smaller books published in series. Encyclopedias, dictionaries, and other reference works were issued in greater number than ever before. At the end of the eighteenth century, lithography (a printmaking method in which a crayon image drawn on a stone is inked and transferred to a sheet of paper) was invented and soon became a popular medium for book illustration.

The nineteenth century saw the rapid growth of the mass-produced book, a flourishing market for newspapers and periodicals, and greatly increased production of the trade catalog. These advancements were facilitated by inventions such as the steam-powered press (1810), automated typecasting, and the Fourdrinier machine (which permitted paper to be produced in rolls instead of single sheets). A number of processes for creating book illustrations were either improved or created at this time. Among them was chromolithography (a lithographic process using several stones or plates, one for each color) that greatly expanded the use of color images in books and provided an alternative to the hand-coloring of illustrations that had been a common practice in earlier centuries. Another process for incorporating color in book illustration was stencil printing, or *pochoir*, which became especially popular in the late-nineteenth- and early-twentieth-century art nouveau and art deco movements. Also at this time, the development of a variety of photographic processes and techniques offered many new possibilities for creating and reproducing illustrations in books.

Toward the end of the nineteenth and on into the twentieth century, a reaction to the mass-produced volumes set in. Several small publishing

houses, inspired by the arts and crafts movement in England, revived the art of creating finely crafted printed books. In the twentieth century, book production changed drastically as advances in typography and photography continued, and as computer graphics were introduced. There is no predicting where a constantly evolving book technology will lead in the future of design. The one hundred titles from the Library's collection that are discussed in *Rare Books* will touch on all the processes and backgrounds discussed above, and may provide inspiration for book makers and lovers of books and design. (Please note that the titles of the books and periodicals discussed here have been reproduced directly from their original title pages, which, of course, carry the spelling in common usage at their time of publication. In the text of this book, references to names, cities, and so forth in these titles are rendered in accordance with current usage.)

I wish to acknowledge and thank a number of colleagues, students, and volunteers who assisted with this book, particularly Elisabeth A. Jakab who spent untold hours editing, revising, and formulating the text into a readable document. Many thanks to the administrations of Smithsonian Institution Libraries, especially Nancy Gwinn, Nancy Matthews, and Bonita Perry; and Cooper-Hewitt, National Design Museum, Linda Dunne, Jeff McCartney, Dianne Pilgrim, and Susan Yelavich, for their support of this project. I would also like to thank the staff, contractors, and volunteers at Cooper-Hewitt, National Design Museum and Smithsonian Institution Libraries for their help with editing, research, and photography. They include Luis Badillo, Jill Bloomer, Elizabeth Broman, Martha Conners, Matt Flynn, Claire Gunning, Elizabeth Johnson, Floramae McCarron-Cates, Paul Makovsky, Leslie Overstreet, Renata Rutledge, Diane Shaw, and Leonard Webers.

Chapter One

Patterns for Inspiration

Since their introduction in the fifteenth century, printed illustrated books in a number of disciplines helped to standardize and promote a variety of decorative styles throughout the world. Besides providing patterns to be copied or adapted, these books also inspired designers to create new and divergent styles. They constitute a unique visual narrative of the origins and transfer of styles in architecture and the decorative arts over several centuries and into our own day. Illustrated natural history books, archaeological and building studies, and compilations of ornamental designs, in particular, all display a wealth of patterns that have sparked and continue to spark creative ideas in architects and designers. The Library contains beautiful examples of all of these types of books.

Natural History

The natural history book, originally intended as a scientific document, quickly also became a frequently consulted resource for designers seeking popular and striking images. Most of the images in these books were derived from the notebooks of scholars and amateur naturalists who illustrated and catalogued their collections of minerals, shells, plants, and animal specimens. Though this type of collecting reached its height in the eighteenth century, many fine herbals and botanicals were created in earlier centuries. A 1623 book by Pierre Vallet (active 1600s), *Le jardin du Roy tres chrestien, Loys XIII, Roy de France et de Navare* (The garden of the very Christian king, Louis XIII, King of France and Navarre) contains more than fifty life-size engravings (fig. 1). The book is an accurate and scientific inventory of the plants and flowers in the garden of King Louis XIII of France. In addition, because Vallet's delicate styling and placement of images give his work an artistic quality, his work was frequently copied by designers of the day.

Opposite

Detail of figure 17

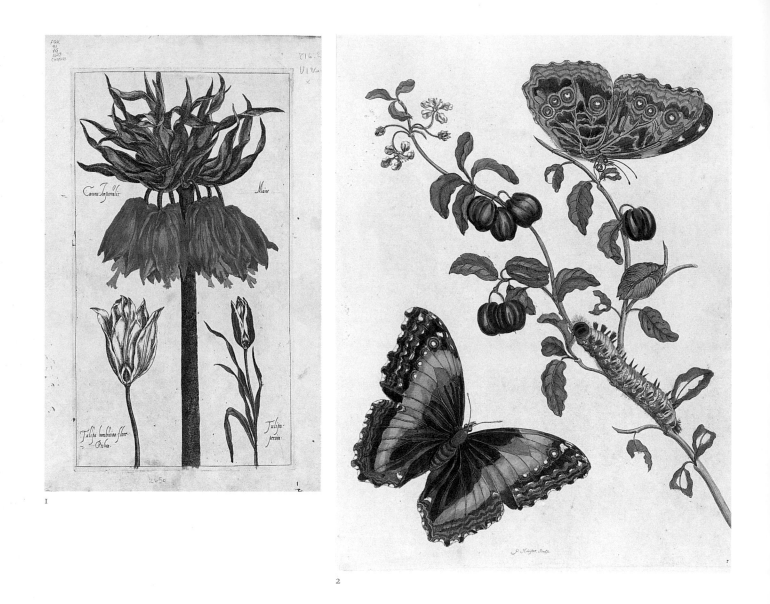

1

2

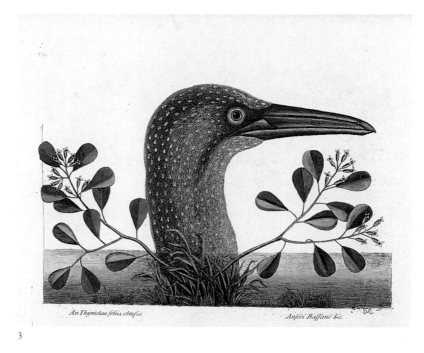

An Thymelæa foliis obtusis. *Anser Bassanus &c.*

3

Many illustrated natural histories record specimens sketched and documented in field notebooks during travels to exotic countries. One remarkable example is *Maria Sybilla Meriaen Over de voortteeling en wonderbaerlyke veranderingen der Surinaamsche insecten* (Maria Sybilla Meriaen on the original forms and miraculous transformations of Surinam insects), by Dutch entomologist Maria Sibylla Merian (1647–1717) (fig. 2). During a two-year visit to Surinam, a Dutch colony in South America, Merian examined, recorded, and made illustrations of hundreds of rare and colorful insects. When she returned to Amsterdam, Merian developed a large folio edition of her notebooks that was first published in 1705. This lavish volume, containing more than one hundred hand-colored engravings based on her original watercolors, was considered the most outstanding work on insects of its day. Merian's accurate and appealing pictures inspired designers for centuries, most recently those at the U.S. Postal Service in 1997, which issued three stamps featuring her designs.

Another naturalist, Englishman Mark Catesby (1683–1749), studied the southeastern United States and the Caribbean from 1712 to 1719, and from 1722 to 1726. He collected specimens, recorded his impressions of wildlife, and sketched a variety of animals in their habitats. His volume

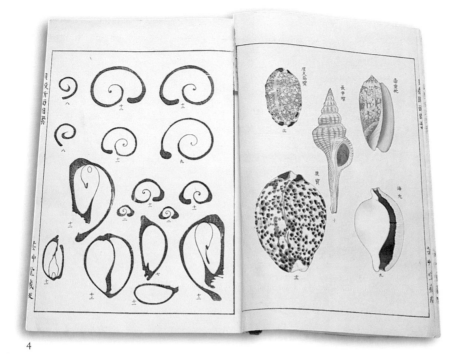

4

4

Hand-colored woodcuts of shells from *Kaigara Danmen Zuan*, by Yoichiro Hirase. 24 × 34 cm. Kyoto: Geisodo, Taisho 2, 1912

5

Magnified photograph of young fronds of American maidenhair fern. Plate 55 from *Urformen der Kunst*, by Karl Blossfeldt. 25 × 32 cm. Berlin: E. Wasmuth, 1928

The natural history of Carolina, Florida, and the Bahama islands, published from 1731 to 1743, is the first major book to illustrate American plants and animals (fig. 3). Like Merian, Catesby artistically situated his subjects in their environment. The illustrations, many of them hand-colored, though not accurate depictions of their subjects, do have a naive charm.

While books like those of Merian and Catesby played an important role in documenting specimens of nature, they also served as design sources for architects, craftsmen, and decorators throughout Europe, beginning in the eighteenth century. Artists in the china manufactories at Meissen, Chelsea, Bow, Bristol, and Swansea created patterns based on these kinds of natural history illustrations. To give one example, at the Chelsea Porcelain Company several plant and floral motifs used on dinner plates were copied directly from an illustrated botanical entitled *Figures of the most beautiful, useful, and uncommon plants* (1760), by Philip Miller (1691–1771), Curator of the Chelsea Physic Garden.

The production of natural history books increased on into the nineteenth century as science became more a profession than a gentlemanly pastime. Scientific books and journals regularly published images of new

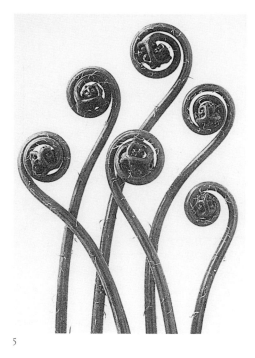

5

species and exotic specimens. All of them were eagerly received by
designers and craftsmen.

Perhaps the clearest example of the use of natural history as a means of
creating patterns is *Kaigara Danmen Zuan* (Cross sections of seashells)
(1912), a curious Japanese study compiled by Yoichiro Hirase (1859–1925)
(fig. 4). The book opens with two pages of hand-colored, scaled-to-size
drawings of shells, which range in shape from ovals to cones. These shell
drawings provide a point of departure for the abstract woodcut block pat-
terns that comprise the rest of the book. The repetitive and decorative
arrangement of these woodcuts suggests Hirase created the patterns
specifically for textile and ceramic designers.

Urformen der Kunst: photographische Pflanzenbilder (Art forms in nature:
examples of the plant world photographed directly from nature), by Karl
Blossfeldt (1865–1932) also provides images of natural forms to be used
by artists and designers (fig. 5). Blossfeldt, a German artist and photogra-
pher, studied how to draw and model plants with the painter Moritz
Meurer (1839–1916). In 1928, he published *Urformen der Kunst*, a collec-
tion of 120 photographs that focus on the intricate details of plants. For
generations, artists have marveled at Blossfeldt's clarity of reproduction,

which reveals the structure of plants in a style that bridges the classical to the organic in an empirical rather than sentimental manner.

Archaeology and History

A different type of book containing patterns evolved in the eighteenth century when European travelers made greater efforts to uncover and assess the ornaments of ancient and medieval civilizations. The field of archaeology expanded as explorers, architects, and amateurs interested in the classics began to seriously examine ancient sites. They wrote many illustrated books with detailed drawings of cities and building complexes, including the colorful patterns found there.

One of these travelers was Robert Adam (1728–1792), a noted British architect and ornamentalist who set out for Rome in 1754 to study architecture. There he met Giovanni Battista Piranesi, who shared his interest in ancient architecture and encouraged him to travel to, examine, and record classical structures. Adam took the advice. In 1757, he and Louis Clerisseau, a French architect, spent five weeks at the ruins of Diocletian's Palace in Spalatro (present-day Split, Croatia). Adam measured walls, recorded ornamental details, and developed accurate floor plans of the palace. On his return to England in 1764, he published a lavish folio volume of his sketches, *Ruins of the palace of the Emperor Diocletian at Spalatro in Dalmatia* (fig. 6). This study greatly enhanced his standing in the European architectural community and established him as a major classicist of the time.

Other travelers, architects, and archaeologists also successfully promoted large folio editions of their descriptions, drawings, and plans of ancient sites. These elaborate eighteenth-century studies of archaeological sites profoundly influenced contemporary designers, who adapted these classical ornamental designs for objects and interiors as well as for the exterior decoration of modern buildings.

Wilhelm Zahn (1800–1871) created equally outstanding books of patterns, but his were based on both classical and Renaissance ornament. Zahn traveled to Italy in the 1820s, where he recorded the ornamental designs on wall paintings in Roman villas at Pompeii and Herculaneum and those on the interiors created by Giulio Romano for the sixteenth-century Palazzo del Te in Mantua. Zahn's *Die schönsten Ornamente und merkwürdigsten Gemälde aus Pompeji, Herculanum, und Stabiae* (The most beautiful ornaments and most curious paintings of Pompeii, Herculaneum, and Stabiae) consisted of a ten-volume series published in

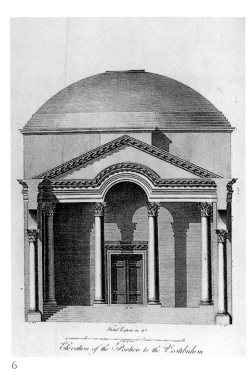

Elevation of the Portico to the Vestibulum.

6

6

Engraving of the elevation of the vestibule portico by Francesco Bartolozzi (1727–1815). Plate 21 from *Ruins of the palace of the Emperor Diocletian at Spalatro in Dalmatia*, by Robert Adam. 40 × 54 cm. London, 1764

7

Color lithographs of wall mural designs inspired by examples at Pompeii and Herculanum. Plate 14 from *Ornamente aller klassischen Kunstepochen*, by Wilhelm Zahn. 39 × 28 cm. Berlin: G. Reimer, 1843

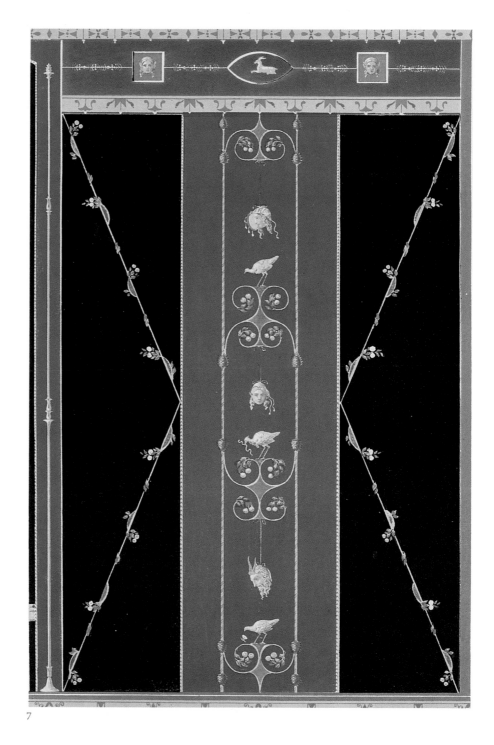

7

Berlin beginning in 1827. It was the first ornament pattern book to be created by color lithography.

Zahn returned to Italy in the 1830s to study classical, medieval, and Renaissance ornaments in preparation for what would become his better-known work, *Ornamente aller klassischen Kunstepochen* (Ornaments of all the classical periods in art) (1831–43) (fig. 7). It has been suggested that this beautiful volume, containing more than two hundred pattern illustrations, was commissioned by the Austrian government to educate designers in the art of using ornament in interiors. It is indeed a very superior pattern book—and the forerunner of the more extensive ornament encyclopedias produced later in the century.

A stunning example of this kind of encyclopedia is *Specimens of ornamental art, selected from the best models of the classical epochs*, by Ludwig Gruner (1801–1882), one of the most sumptuous books depicting ornamental details in buildings (fig. 8). Gruner studied in Dresden, then in Rome, before moving to England in the early 1840s. Appointed art adviser to Prince Albert in 1843, he contributed to the interior decoration of Buckingham Palace, and subsequently the Government School of Design commissioned him to create a book of historic patterns for design students. The development of this folio (with an accompanying text volume by Emil Braun) took ten years. With its oversized format *Specimens* was the largest book printed in the nineteenth century. Containing eighty color plates, the work included illustrations inspired by floral decorations, bronze and iron gate patterns, painted wall and ceiling details, inlaid floor designs for wood and tile, ornate bookbindings, and Pompeian frescos, among others. Most impressive are the detailed studies of vibrant, highly ornate architectural interiors by such artists as Luini, Giotto, Giulio Romano, and Raphael. Among his illustrations of these interiors, Gruner frequently inserts full-size ornamental details that can easily be duplicated by students, and that also serve to convey a sense of the size of the original space.

The publication of books of patterns based on archaeological sites and the study of building monuments continued in the nineteenth century. However, instead of focusing on classical monuments, they began to reflect the growing public interest in the exotic Middle East and Islamic culture. The Alhambra, an ornate palace in Spain constructed between 1238 and 1358 by the Moorish ruler Al Ahmar and his successors, became a hugely popular subject.

The most remarkable, colorful, and accurate study of the Alhambra was

8

Color lithograph of ceiling painting in the sixteenth-century church of St. Francesco at Lodi, Italy. Plate 49 from *Specimens of ornamental art, selected from the best models of the classical epochs*, by Ludwig Gruner. 51 × 65 cm. London: T. McLean, 1850

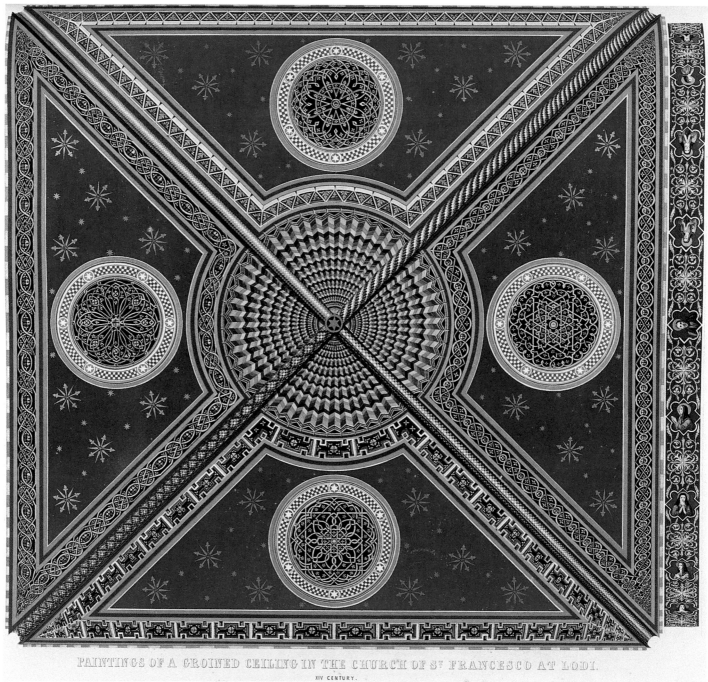

PAINTINGS OF A GROINED CEILING IN THE CHURCH OF ST FRANCESCO AT LODI.

XIV CENTURY.

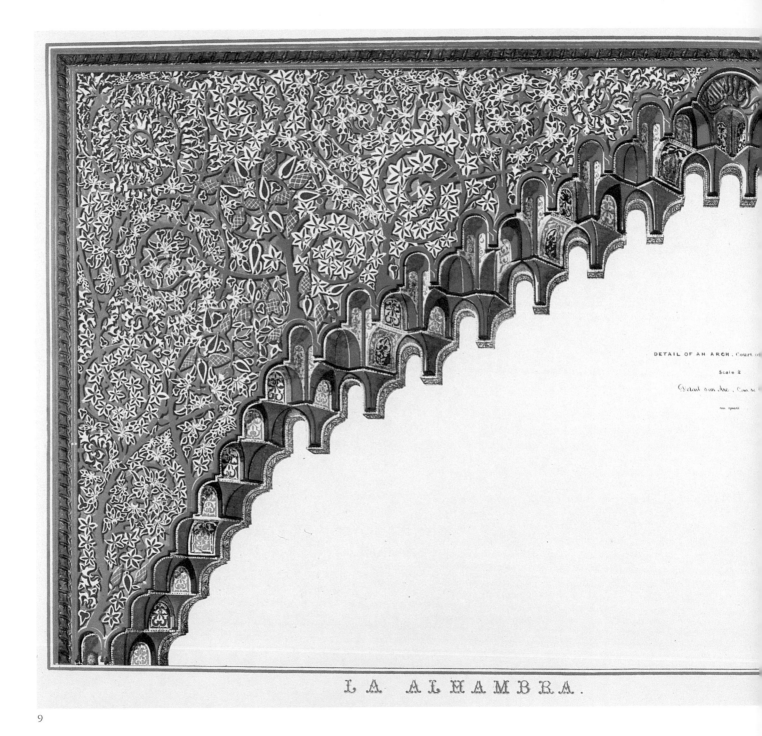

DETAIL OF AN ARCH. Court of

Scale ⅛

Detail d'un Arc. Cour de

L A A L H A M B R A .

9

9

Color lithograph of an arch detail
from the court of the fish pond at
the Patio de la Alberca. Volume 1,
plate 30, from *Plans, elevations,
sections, and details of the Alhambra*,
by Jules Goury and Owen Jones.
52 × 60 cm. London: O. Jones,
1842–45

Plans, elevations, sections, and details of the Alhambra (1842–45), by Jules
Goury (1803–1834) and Owen Jones (1809–1874) (fig. 9). Jones, the well-
known British architect, designer, and theorist, initially encountered
Islamic patterns and architecture during his travels in Greece, Turkey, the
Holy Land, and Egypt in the 1830s. He shared his newfound interest with
Goury, a young French architect. On a visit to the Alhambra in 1834, the
two men decided to conduct an exhaustive study that would accurately
illustrate the intricate geometric patterns and shapes of the palace's decor-
ative ornaments. Goury died in 1834 of cholera, but Jones persevered
with the study as a tribute to Goury. The illustrations in these elaborate
volumes, dated 1836, are the earliest examples of color lithography in
England.

The first folio (1842) contains hundreds of illustrations, translations of
the Arabic script, rendered in the angular Kufic style on the building, and
an essay on the palace by Pascual de Gayangos, a scholar of Spanish Arab
civilization. The second volume, with fifty chromolithographic images of
decorative fragments, was created to supply designers, ornamentalists,
and manufacturers with ornamental details to study and copy. *Plans, eleva-
tions, sections, and details of the Alhambra* engendered enormous popular
enthusiasm for the Islamic style, and European and American designers
eagerly copied its illustrations. The book ultimately established Jones as a
leading authority on ornament.

Original Designs
The Library collection also includes examples of books containing
unique, original, and visionary ornamental patterns. These volumes
chronicle the history of ornament in major design movements over the
last five hundred years.

One of the earliest examples of this type of book is *Oeuvre de la diversité
des termes* (Work on the diversity of terms of designs) (1572) (fig. 10), a
sixteenth-century book of patterns for furniture by Hugues Sambin
(1520–1601). An architect, woodcarver, and engineer who worked for
Henry II, Sambin compiled this book, which contained thirty-six carved
images of decorative supports for furniture, as a guide for designers. In
those days, the training of craftsmen included not only a thorough
grounding in the use of tools and techniques, but also learning how to
adapt and creatively employ ornament design. From the sixteenth through
the nineteenth century, designers regularly used guides such as Sambin's
as a starting point in developing ornamental patterns for furniture.

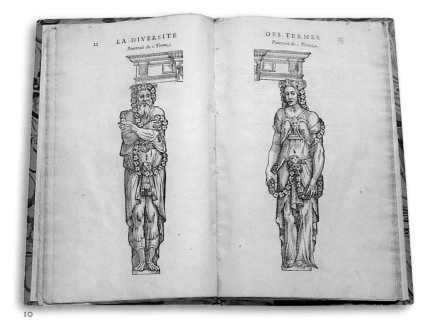

10

In a similar manner, Jean Le Pautre (1618–1682), one of the most prolific French ornamentalists of the seventeenth century, produced nearly two thousand patterns for designers. His books of visionary designs for moldings, ceilings, mantels, vases, friezes, silver, chimneys, and furniture helped spread the French baroque style throughout Europe. *Ornaments de pannaux* (Ornaments for panels), published from 1641 to 1667, contains more than forty examples of his ornate designs for garden grottos, medallions, and church and palace walls (fig. 11).

An equally influential, yet playful, book of patterns featuring *singerie* (a type of European decoration inspired by exotica that depicts monkeys dressed in human clothing mimicking activities such as hunting, dancing, and playing musical instruments) is Christophe Huet's (1700–1759) *Singeries, ou, Differentes actions de la vie humaine représentées par des singes* (Antics, or, different activities of human life portrayed by monkeys) (1750) (fig. 12). Huet employed witty *singerie* motifs in the decoration of interiors in the Hotel de Rohan in Paris and in the chateau of Chantilly. Huet often placed the monkeys in Chinese settings to appeal to the eighteenth-century taste for chinoiserie.

Books of Renaissance designs were also popular in the late eighteenth century. *Le Loggie di Rafaele nel Vaticano* (Raphael's loggias at the Vatican)

10

Engraving of patterns for carved furniture. Plates 16–17 from *Oeuvre de la diversité des termes,* by Hugues Sambin. 22 × 34 cm. Lyon: Jean Durant, 1572

11

Engraving of wall decorations in a palace. Plate 29 from *Ornaments de pannaux,* by Jean Le Pautre. 32 × 20 cm. Paris: van Merlen, 1641–67

12

Hand-colored etching and engraving of monkeys as musicians, from *Singeries, ou, Differentes actions de la vie humaine représentées par des singes,* by Christophe Huet. 31 × 12 cm. Paris: Chez Guélard, c. 1750

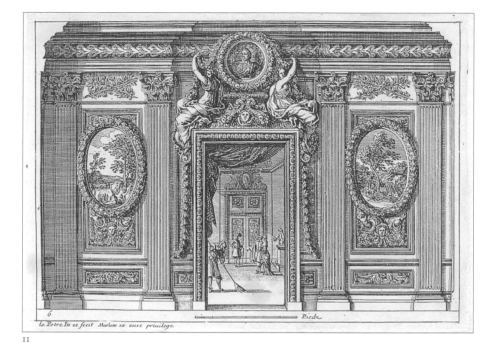

11

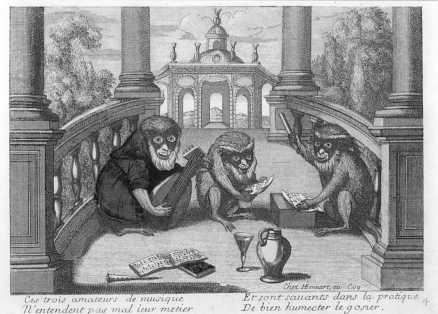

12

(1772–77), a book based on Raphael's ornamental grotesques and arabesque designs for the Loggia at the Vatican, was a major source for painters, sculptors, architects, goldsmiths, and embroiderers. Michel Angelo Pergolesi (active 1700s), an Italian designer and engraver who worked with Robert Adam in England, was greatly influenced by Raphael. Pergolesi's 1777–92 *Collection of original designs of vases, figures, medallions, friezes, etc.,* a compilation of more than 150 of Pergolesi's graceful arabesques and patterns for walls, furniture, and metalwork based on Raphael's Vatican Loggia designs, promoted the Adamesque style throughout Europe (fig. 13).

In the nineteenth century, a series of colorful and beautifully designed books containing patterns were produced that aspired to be encyclopedic by examining ornament from a variety of cultures and historic periods. Owen Jones's 1856 book, *The Grammar of Ornament,* was the first to systematically analyze ornamental art from different eras (fig. 14). Jones, a noted British designer and architect who coauthored the book on the Alhambra mentioned earlier, created the grammar to educate designers. His book stressed the need for a vigorous study of historic styles in preparation for an ornamental language suitable to the new industrial age. Jones and his assistants developed all the designs for the book by drawing on patterns from all over the world, including non-Western cultures. In addition to providing unprecedented information, the book is clearly one of the nineteenth century's great monuments of chromolithographic printing.

Books containing patterns and advocating the use of specific styles of ornament were created throughout the nineteenth century by such well-known designers as A. W. N. Pugin, Eugène Viollet-le-Duc, Christopher Dresser, and G. A. Audsley, among others. A fine example in the Library's collection, *La plante et ses applications ornementales* (The plant and its ornamental applications) (1896), was compiled by Swiss designer Eugène Grasset (1841–1917) in collaboration with his student, M. P. Verneuil (1869–1942) (fig. 15). It contains more than seventy curvilinear patterns of plant forms that served as popular motifs for designers working in the art nouveau style.

In the first part of the twentieth century, design magazines such as *The Studio, Dekorative Kunst* (Decorative art), and *Art et décoration* (Art and decoration) continued the tradition of the previous century by including large numbers of contemporary patterns in each issue. *Die Fläche* (The surface) was a journal published from 1903 through 1910 by the Wiener

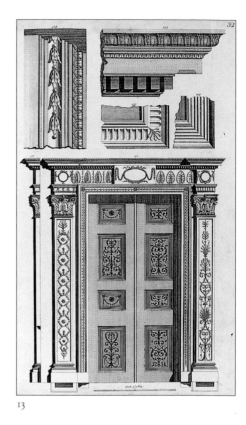

13

13

Engraving of patterns for borders and doors. Plate 32 from *Collection of original designs of vases, figures, medallions, friezes, etc.,* by Michel Angelo Pergolesi. 31.5 × 52 cm. London, 1777–92

14

Color lithograph of medieval patterns inspired by illuminated manuscripts. Plate 71 from *The Grammar of Ornament,* by Owen Jones. 38 × 56 cm. London: Day and Son, 1856

14

15

15

Color lithograph designs in the art
nouveau style by M. P. Verneuil.
Plate 11 from *La plante et ses applica-
tions ornementales*, compiled by
Eugène Grasset. 33.5 × 47 cm.
Paris: Librarie centrale des Beaux-
arts, E. Lévy, 1896

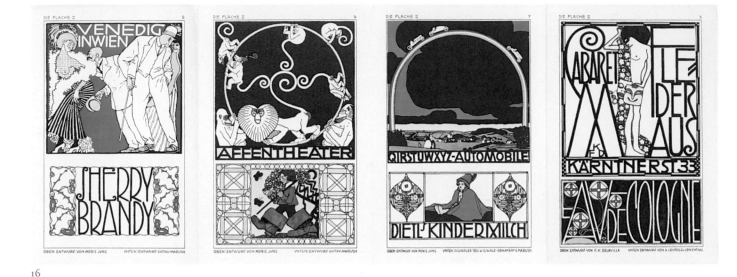

16

Werkstatte, a Viennese craft studio founded in 1903 by Josef Hoffmann (1870–1956) and Koloman Moser (1868–1918) (fig. 16). Each issue, featuring the work of students and faculty, consisted entirely of inspirational images promoting colorful rectilinear patterns and objects made at the studio.

Throughout the twentieth century, books of ornamental patterns produced by using the latest technologies in typography, photoengraving, and stencil printing were created by artists such as Sonia Delaunay, Emile Ruhlman, and E. A. Seguy. The demand for these books continued in tandem with the rise of the modernist movement represented by the Bauhaus and the International Style, which advocated a minimum of ornament. Edouard Benedictus (1878–1930), a French painter and designer, published *Relais 1930* (Relay 1930), a well-received portfolio of more than forty *pochoir* stenciled plates in the "moderne" style (fig. 17). Like many folios produced later in the century, *Relais 1930* provided a variety of patterns that influenced interior, industrial, ceramic, wallcovering, and textile designers throughout the world.

The natural histories, archaeological and building studies, and volumes of original patterns discussed here are just a few examples of the several hundred ornament books in the Library's collection and the thousands that were published through the centuries. While giving a unique insight into the taste of each era, they also serve to document the major ornamental styles that educated and inspired each era's designers.

16

Color lithograph posters from the Weiner Werkstatte studio, from *Die Fläche*, volume 2, book 1. Folded: 21 × 31 cm; unfolded: 81 × 31 cm. Vienna, 1910

17

Pochoir designs. Plate 13 from *Relais 1930*, by Edouard Benedictus. 38 × 48 cm. Paris: Vincent, Fréal, 1930

17

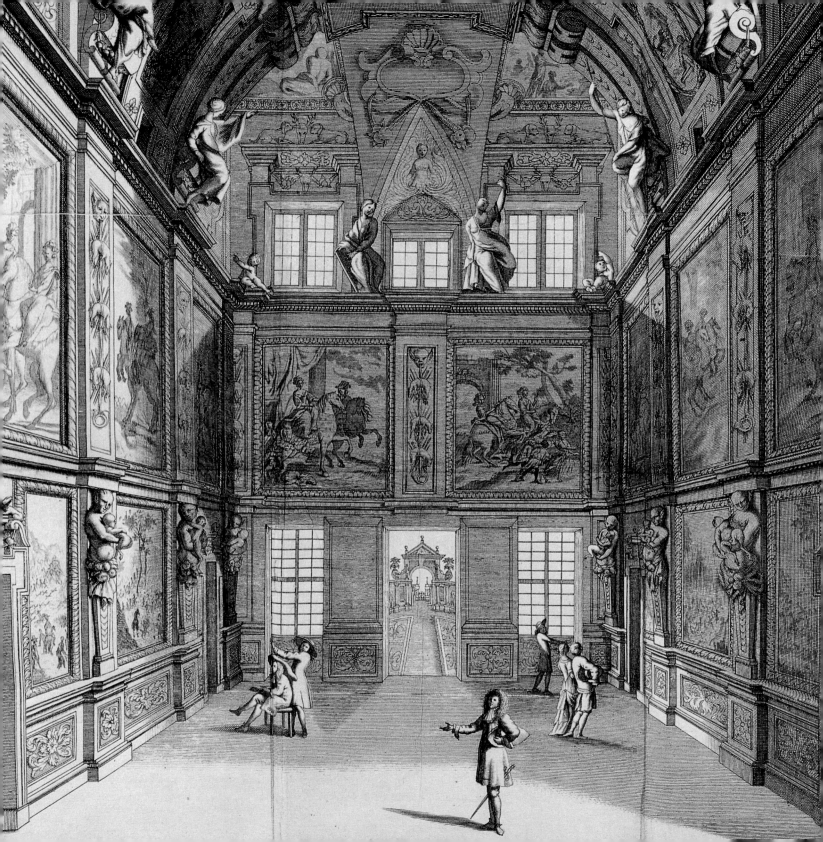

Cultural Aspects of Design

Illustrated books from past centuries often assume new roles as they travel through time. There are several hundred such titles in the Library's collection, originating from countries around the globe, on subjects such as the history of taste, collecting and ownership, political and cultural history, etiquette, commemorative events, and travel. Today, these books shed light on the issues, class structure, economics, explorations, monuments, mores, pastimes, styles, and religious practices of those earlier eras. Some are the sole remaining records that, for instance, prove the existence of a garden or a building, illustrate how to set a table in early eighteenth-century France, or convey the grandeur of a coronation. Scholars now study these titles not only to re-create the past, but also to investigate the link between the events and rituals of a society and the decorative objects it produced.

Collecting and Ownership

Limited-edition books promoted the work of the author-designer and functioned as status symbols for their wealthy subscribers. One famous example is *Venaria reale* (1674), by Amedeo di Castellamonte (active seventeenth century), which depicts the magnificence of the Venaria Reale, an elaborate hunting palace Castellamonte designed and built in the 1660s for Charles Emanuel II, Duke of Savoy (fig. 18). Although the French destroyed the palace in 1693, the book survives as a testament to the taste and opulent style of the time, as well as to the achievement of the architect and, not least, to the wealth and power of Charles Emanuel, who may have subsidized this detailed and expensive book.

The history of taste is also documented in the published inventories of wealthy collectors. From the Renaissance through the eighteenth century, many cultivated Europeans collected natural and man-made items, which

Opposite

Detail of figure 18

18

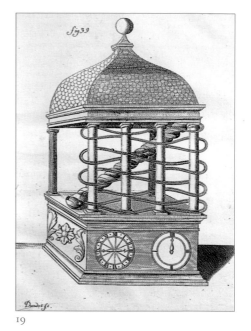

18

Engraving of hunting palace
interior. Plate 1 from *Venaria reale*,
by Amedeo di Castellamonte.
22 × 30 cm. Turin: Bartolomeo
Zapatta, 1674

19

Engraving of a clock. Plate 15 from
*Recueil d'ouvrages curieux de
mathematique et de mecanique*, by
Gaspard Grollier de Servière
(1677–1745). 20.5 × 27 cm. Second
edition, Paris: C. A. Jombert, 1751

20

Hand-colored engraving of shells
arranged in ornamental patterns.
Figure 27 from *Locupletissimi rerum
naturalium thesauri accurata
descriptio*, by Albert Seba. 36 × 54
cm. Amsterdam: Janssonio-
Waesbergios, 1734–65

they exhibited in specially designed display rooms known as cabinets of
curiosities. A book on the cabinet of Nicolas Grollier de Servière
(1596–1689), entitled *Recueil d'ouvrages curieux de mathematique et de
mecanique* (Collection of mathematical and mechanical curiosities) (1751),
written by his grandson Gaspard, focuses on his collection of mechanical
devices, which included fantastic clocks, drills, and pumps (fig. 19). The
inventory also provides illustrations of carved ivory globes that Grollier de
Servière both collected and made.

Albert Seba (1665–1736), a Dutch apothecary and amateur naturalist,
compiled a much more extensive cabinet of curiosities. Seba's collections

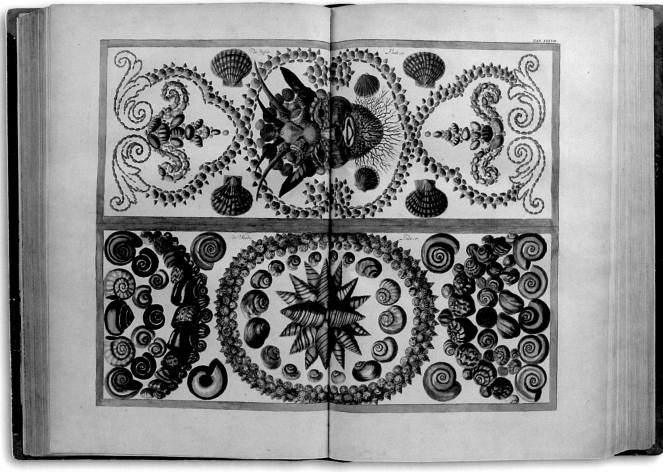

20

of jewels, carved objects, botanical specimens, shells and fish, and
precious minerals were considered the finest in Europe. In 1717, he sold
his natural history specimens to Czar Peter the Great. Seba later amassed
a second, even larger, natural history collection. He published illustra-
tions of this collection in a four-volume set entitled *Locupletissimi rerum
naturalium thesauri accurata descriptio* (The most copious treasury of accu-
rately described natural specimens) (1734–65) (fig. 20). These beautiful
folios, with hundreds of hand-colored engravings, feature specimens
arranged in ornamental patterns, much as they may have been exhibited
in the large display drawers in Seba's cabinet.

21

Political and Social Commentary

Works stressing economic and social reform as well as those with satirical
and propagandist images are well represented in the collection. The
connection between propaganda and design is perhaps best seen in a
Ukrainian porcelain catalog entitled *Katalog farforu faiansu i maioliky*
(Catalog of fayence and maiolica) (1940) (fig. 21). Among the hundreds of
conservative patterns for tableware and ceramic pieces produced by the
state-controlled Soviet porcelain factory in Kiev are several examples of
politically motivated ones, including idealized images of Lenin and
Stalin, workers on collective farms, and military equipment.

Your house is mine (1989, 1991), an American book compiled and edited
by Andrew Castrucci, Paul Castrucci, and Nadia Coen is a fine example of
a work advocating social reform and empowerment in the twentieth century
(fig. 22). Inspired by the August 1988 riots that erupted after the eviction
of squatters from Tompkins Square Park in Manhattan's East Village, the
book consists of street posters by a group of homeless artists known as Bullet
Space. The goal of this collection is to act as an "art of resistance" against
the powerful real estate owners who control the city's housing market.
Bullet Space uses bold and shocking images to depict the plight of the urban
poor, sick, and homeless and their need for decent, affordable housing.

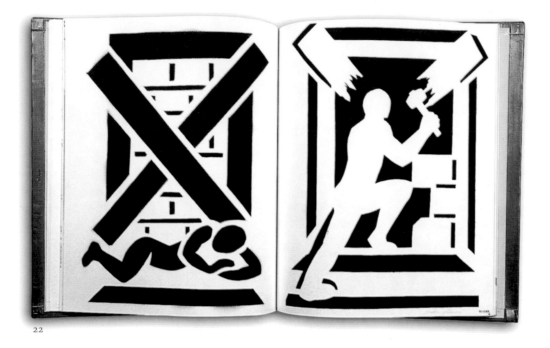

22

History of Social Customs and Taste

Customs, rituals, mores, and class status also greatly influenced the production of decorative objects. Contemporary guides to etiquette; proper dress and grooming; cooking and entertaining; fashion; home furnishing, decorating, and management; educating children; and managing servants; along with personal narratives of daily life, all provide valuable information on period taste, ornament, and the items needed or considered important in each era.

One good example of this type of guide is a cookbook, *La nouvelle cuisine: avec de nouveaux desseins de tables et vingt-quatre menus* (The new cuisine: with new table settings and 24 menus) (1751), by Menon (active eighteenth century) (fig. 23). It includes recipes, servicing techniques, and a list of implements for setting a table. Menon also illustrates carving methods and the proper arrangement of the silver and porcelain for a formal dinner.

Similarly, etiquette guides, sporting titles such as *Principles of politeness* (1786), *How to be a lady* (1847), and *The American gentleman* (1836), illuminate the manners and life styles of earlier times. *The American toilet* (c. 1827) (figs. 24a, 24b), by Hannah Lindley Murray (1777–1836), is a especially witty example. This colorful pop-up book contains twenty emblematic

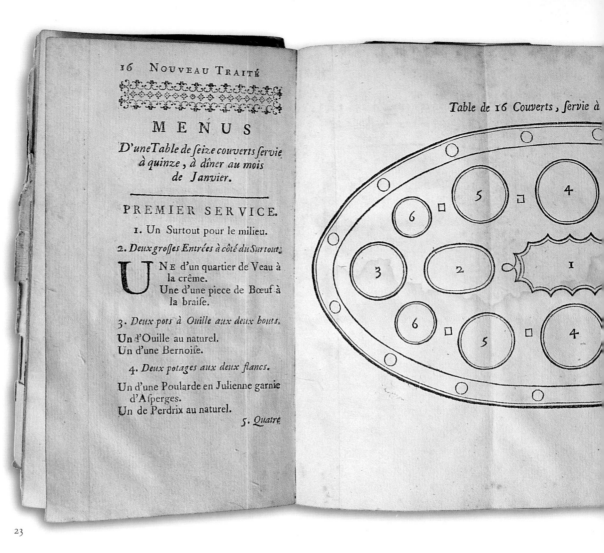

MENUS

D'une Table de seize couverts servie à quinze, à dîner au mois de Janvier.

PREMIER SERVICE.

1. Un Surtout pour le milieu.

2. *Deux grosses Entrées à côté du Surtout.*

UNE d'un quartier de Veau à la crême.
Une d'une piece de Bœuf à la braise.

3. *Deux pots à Ouille aux deux bouts.*

Un d'Ouille au naturel.
Un d'une Bernoise.

4. *Deux potages aux deux flancs.*

Un d'une Poularde en Julienne garnie d'Asperges.
Un de Perdrix au naturel.

5. *Quatre*

Table de 16 Couverts, servie à

23

23

Woodcut depicting a table top for a place setting. Volume 1, page 16, from *La nouvelle cuisine*, by Menon. 11 × 17 cm. Paris: David Pere, 1751

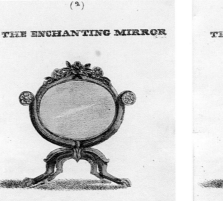

24a 24b

24a and 24b

Hand-colored lithograph entitled "The Enchanting Mirror." Page 2 from *The American toilet*, by Hannah Lindley Murray. 10.5 × 14 cm. Second edition, New York: Imbert's Lithographic Office, c. 1827

images of jewelry, cosmetics, and other objects from a woman's dressing table, together with a moral for each drawing. Every image has a hinged flap that, when lifted, reveals the name of an associated virtue. The "toilet book," a genre that was the precursor to *The American toilet*, was originally developed in England by William Grimaldi in 1821. For a party entertainment, he sketched each article on his daughter's dressing table on the top flap of a folded sheet of paper, then drew a scene illustrating a corresponding virtue inside the fold. This informal little series later evolved into a published book of instruction for young women.

Serial publications, aimed mainly at upper-class women, reported the latest trends in dress and etiquette. They provide a unique insight into the everyday life of wealthy women in the late eighteenth through early twentieth centuries. Among them is *Toiletten-Geschenk: ein Jahrbuch für Damen* (Toilet gifts: a yearbook for ladies) (Leipzig, 1805–8), which contained musical scores, embroidery and sewing patterns, dance instructions, home decorating tips, and articles on taste, art, religion, and literature (fig. 25).

Books on personal hygiene, grooming, and dress also give us valuable information on contemporary styles and tastes. The Library's collection includes two fascinating eighteenth-century manuals on hairdressing, haircutting, and adornment, written for professional artisans, valets, and "ladies women." The first, *Plocacosmos, or The whole art of hair dressing*

25

25

Engraving illustrating proper bowing and dance etiquette. Page 112 from *Toiletten-Geschenk*. 23 × 19 cm. Leipzig: G. Voss, 1807

26

Hand-colored engraving depicting hairstyle with three rows of curls. Plate 12 from *L'art de la cöeffure des dames françoises*, by le sieur Legros. 17 × 23 cm. Paris: Antoine Boudet, 1768

(1782), by James Stewart (active eighteenth century), provides instructions on the use of wigs, perfumes, and cosmetics; on hairstyles and the trimming of facial hair; on suitable theater costumes; and exhortations on behalf of moral living to ensure one's health and happiness. The second, *L'art de la coëffure des dames françoises* (The art of coiffure for French ladies) (1768), by le sieur Legros (active eighteenth century), is one of the earliest manuals dedicated solely to the art of styling women's hair (fig. 26). Legros, stylist to Queen Maria Thérèse Leczinska, wife of France's King Louis XV, established the standards for proper styles. His illustrations of hair-cutting techniques and tool use could be easily copied by fellow craftsmen. The book's hand-colored engravings, numbering more than twenty-five, depict elaborate hairdos, many with fanciful ribbons and feathers. An English translation quickly spread these French hair designs to Great Britain and America. Besides documenting the era's hairstyles, this guide gives us an insight

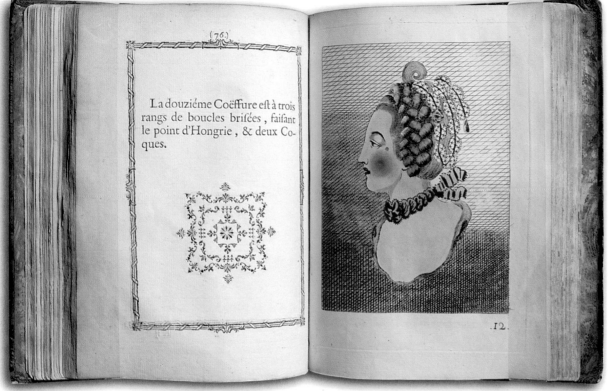

(76.)

La douziéme Coëffure eſt à trois rangs de boucles briſées, faiſant le point d'Hongrie, & deux Co-ques.

.12.

26

into the unrestrained opulence of French fashion in the latter part of the eighteenth century.

Home management and decorating guides, geared to the growing middle class, offer information on the day-to-day activities, taste, decor, and objects needed to run households in the nineteenth century. Among such manuals were *Mrs. Beeton's book of household management* (1861), by Isabella Beeton (1836–1865); and *The American woman's home* (1869), by Catharine Beecher (1800–1878) and Harriet Beecher Stowe (1811–1896). Clarence Cook (1828–1900), an American art critic and journalist who wrote several manuals on interior decoration, gives us a look at the ideal American Victorian home in *The house beautiful* (1878), one of the era's most popular home-decorating guides (fig. 27). Cook also urges the use of decorative antiques, provided they are both aesthetic and functional.

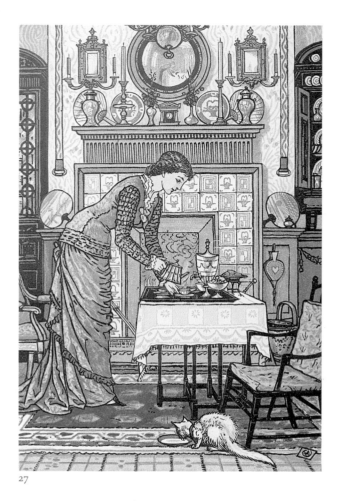

27

28

Commemorative Books

Books that document important events and ceremonies also help us understand the role of design objects in social, political, and economic history. Frequently, they provide the most detailed—and sometimes, the only—record of an event. Many such volumes include valuable information on the food served and the place settings used; the costumes and rituals for religious or state ceremonies; and the objects and interior displays used in trade and world fairs and theater sets. Whether printed in limited editions for an elite clientele or in larger quantities as travelers' souvenirs, each volume was intended as a keepsake. Today, historians and designers use such books to reconstruct these special occasions, and

27

Photomechanical reproduction of a color lithograph depicting an American interior. "My Lady's Chamber" by Walter Crane, frontispiece from *The house beautiful*, by Clarence Cook. 19.5 × 25 cm. New York: Scribner, Armstrong & Company, 1878

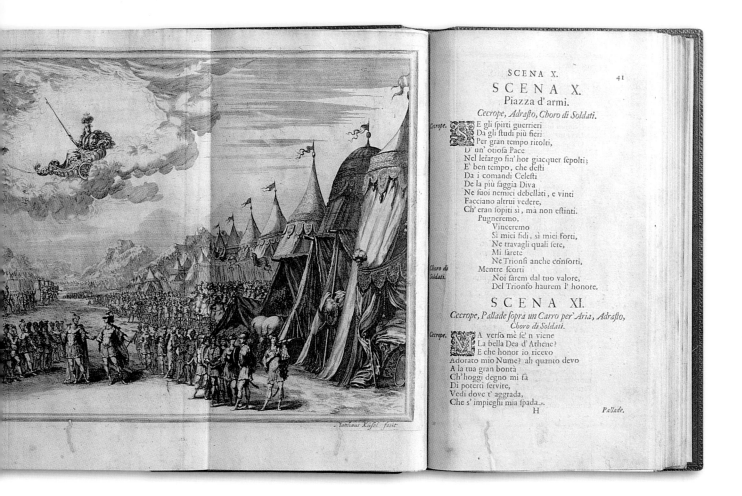

28

Etching and an engraving depicting
a stage set delineated by Lodovico
Burnacini (1636–1700) and
engraved by Matthaeus Küsel
(1629–1681) from scene 10, act 2
of the opera, *Il pomo d'oro*, by
Francesco Sbarra. 19.5 × 32 cm.
Vienna: Matteo Cosmerovio, 1668

even as guides for re-creating the particular era's fashions, theater sets,
and architecture.

One example of such a resource is the libretto for *Il pomo d'oro* (The
golden apple) (1668), an opera written by Francesco Sbarra (active seven-
teenth century), with music by Pietro Antonio Cesti (1623–1669) (fig. 28).
Il pomo d'oro is based on the Judgment of Paris, a Greek myth in which the
mortal Paris must decide which goddess will receive a coveted golden
apple. Cesti, a musician, singer, and vice-Kappellmeister (assistant direc-
tor of music) at the court of Emperor Leopold I of Austria, composed the
opera in celebration of Leopold's marriage to Margherita Teresa of Spain.
One of the most lavish Baroque court operas of all time, it runs eight
hours and has five acts, sixty-six scenes, and twenty-three stage sets,

29

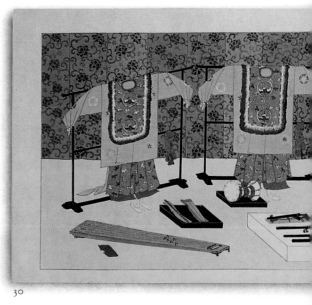

30

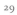

29

Engraving after a drawing by Pierre Dulin (1669–1753) of the royal coronation banquet from *Le Sacre de Louis XV, roy de France & de Navarre*. 51.5 × 69 cm. Paris, 1723

30

Color woodcut by Korin Furuya of a Japanese ceremony from *Kyugi soshoku jurokushiki zufu*, by Asamaro Inokuma. 37 × 25 cm. Kyoto: Kyoto Bijutsu Kyokai, 1903

which required specially designed machinery to operate. Engravings of the stage sets appear throughout the libretto. The sets, many with painted backdrops and ceilings, illustrate battles and earthquakes, panoramic landscapes and gardens, fantastic figures floating in the sky, and magnificent colonnaded palaces. They attest to the extravagance of the era, and were perhaps designed to rival similarly lavish spectacles created by Louis XIV at Versailles.

Equally elaborate volumes record and commemorate coronations, particularly in France and England. Two notable ones are *Le Sacre de Louis XV, roy de France & de Navarre* (The coronation ceremony of Louis XV, King of France and Navarre) (1723) (fig. 29) and *Sacre et couronnement de Louis XVI. roi de France et de Navarre* (The consecreation and coronation of Louis XVI. King of France and Navarre) (1775). Both contain numerous engraved illustrations that give us a scene-by-scene account of each coronation. In *Le Sacre de Louis XV*, for example, the first ten chapters each cover one segment of the day-long ceremony, beginning with the preparation of the young king, going on to the coronation, and ending with the royal banquet. Besides depicting the coronation ritual, such commemoratives shed light on the relationship between church and state and the nature of the political power structure, as well as on contemporary dress, modes of travel, and the architectural spaces used for these ceremonies.

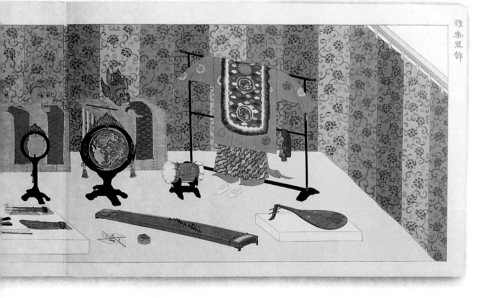

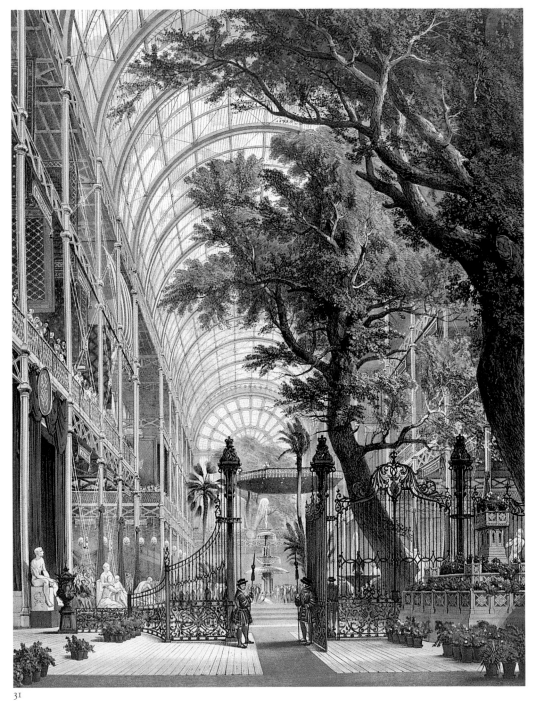

31

31

Artist's proof, color lithograph of
the interior of the Crystal Palace by
David Roberts (1796–1864).
Frontispiece from *Dickinson's
comprehensive pictures of the Great
Exhibition of 1851*. 52 × 61 cm.
London: Dickinson, Brothers, 1854

32

Color lithograph of Chinese and
Japanese porcelain. Plate 282,
volume 3, from *Masterpieces of
industrial art & sculpture at the
International exhibition, 1862*, by
John Burley Waring. 31 × 43 cm.
London: Day and Son, 1863

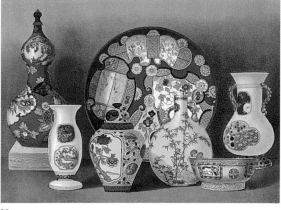

32

Another beautiful commemorative in the collection is a Japanese book that folds like an accordion, entitled *Kyugi soshoku jurokushiki zufu* (Sixteen pictorial charts of ancient ceremonial decoration) (1903), by Asamaro Inokuma (fig. 30). This folio of hand-colored woodblock illustrations by Korin Furuya, was created for the members of the Fine Arts Society in Kyoto. It offers views of Japanese household interiors, each containing the objects, furniture, decorations, implements, musical instruments, and costumes needed to enact cultural rituals such as the art of flower arrangement, marriage, poetry contest, tea ceremony, and coming of age ceremony. The book thus provides a unique view of traditional Japanese social life and customs. Its illustrations also document various decorative patterns on kimonos, wall hangings, screens, lacquered boxes, tables, benches, and ceramic objects. The folio, itself a work of art, is a superior example of a book that creatively depicts the cultural aspects of design.

International Expositions

Books, reports, souvenirs, and guides concerning international expositions and world fairs, of which the library has a large number, are another source of information on contemporary culture, style, and technology. Though small national trade fairs took place in the early nineteenth century, particularly in England and France, London's 1851 Crystal Palace Exposition is considered the first major international exhibition. Housed in Joseph Paxton's innovative glass and cast iron structure, the Exposition displayed thousands of manufactured and hand-crafted products from around the world. The goal of the fair, sponsored by a royal commission headed by Prince Albert, was to educate the public in the latest designs and technologies, to promote industrial growth, and to celebrate the best of crafts.

Two examples from the collection record this Exposition in very different ways. *The Journal of design and manufactures* (1849–52), a periodical published by Henry Cole (1808–1882), includes critical articles on the many poorly designed, machine-made objects exhibited. Cole, an industrial designer, teacher, and organizer of the fair, championed good design, and regularly cited bad and good examples in *The Journal*. His detailed descriptions and editorial comments provide a comprehensive view of the style and technology exhibited at the fair. In contrast, *Dickinson's comprehensive pictures of the Great Exhibition of 1851* (1854), an extravagant commemorative dedicated to Prince Albert, concentrates on the fair's interior displays (fig. 31). The folio, with more than fifty chromolithographs,

each highlighting a particular display, offers the dazzled viewer a rich re-creation of what it must have been like to be inside the Crystal Palace.

The huge success of the 1851 fair inspired a succession of regularly scheduled world expositions. Numerous souvenir histories, guidebooks, commemoratives, and personal accounts documenting the fairs' activities and displays also illuminate contemporary issues, trends, and popular taste. *Masterpieces of industrial art & sculpture at the International exhibition, 1862* (1863), by John Burley Waring (1823–1875), is a three-volume history of the 1862 fair (fig. 32). In it, Waring, a superintendent of the exhibition's architecture and decorative arts galleries, features both the remarkable variety of new inventions and the displays of fine and decorative art. More than three hundred drawings depict currently popular patterns and colors. Perhaps the most notable illustrations are of decorative objects from Japan, a first-time exhibitor, which greatly influenced contemporary designers, as well as artists such as James Whistler and the Herter Brothers.

Exposition publications also provide information on the writings, accomplishments, concerns, handicrafts, and art of women. Some world fairs in the nineteenth century, notably in the United States, dedicated separate areas and pavilions to works by women; they also held forums on women's education, writing, art, and health. *Art and handicraft in the Woman's building of the World's Columbian exposition, Chicago, 1893* (1893), edited by Maud Howe Elliott (1854–1948), was one of the first books dedicated solely to women's art (fig. 33). It contains descriptions and illustrations of hundreds of women's paintings, sculptures, and crafts exhibited at the Chicago exposition in 1893–94. The book also has articles by women's rights advocates on subjects such as women's suffrage and equal opportunity in education and work.

In the twentieth century, world fairs tended to lose the grandeur and pomp of the previous era. Though the idea of international competition and cooperation continued, later expositions focused primarily on advances in science and technology that promised to improve people's quality of life. For example, the *Official souvenir book of the New York World's Fair, 1939* (1939), written by Frank Monaghan (1904–1969), features futuristic trends in technology, communication, energy, architecture, transportation, urban planning, medicine and public health, and manufacturing—all of them promoting the fair's theme, "the world of tomorrow" (fig. 34). Even the book's design, by industrial designer Donald Deskey (1894–1989), supports this modernist theme with a creative use of page layout, typography, and photomontages.

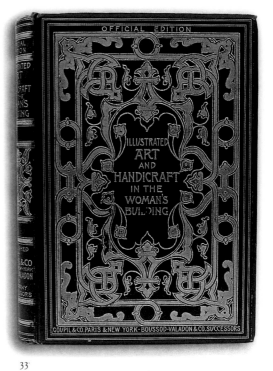

33

33

Embossed leather cover. *Art and handicraft in the Woman's building of the World's Columbian exposition, Chicago, 1893*, edited by Maud Howe Elliott, 18 × 25 cm. New York: Boussad, Valadon & Co., 1893

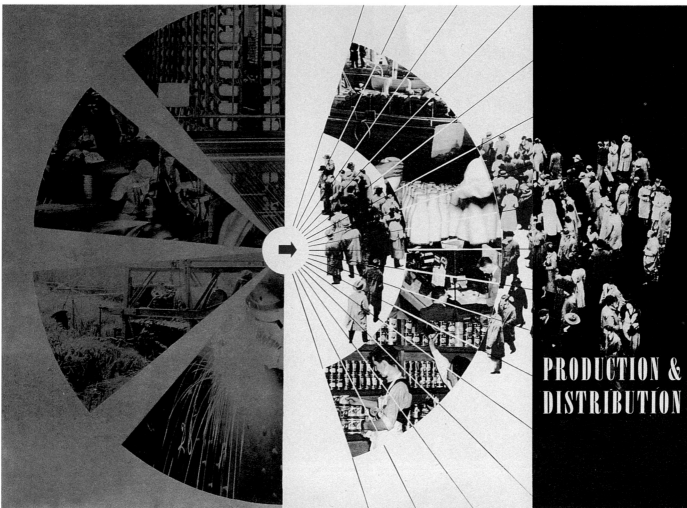

34

34

Photomechanical reproduction of a
photomontage designed by Donald
Deskey from *Official souvenir book of
the New York World's Fair, 1939*, by
Frank Monaghan. 35.5 × 21 cm. New
York: Exposition Publications, Inc.,
1939

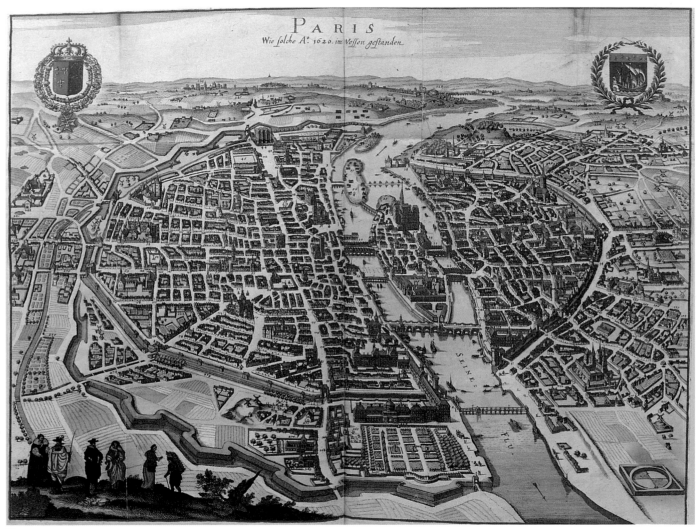

35

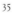

Travel

Another kind of illustrated book, the travel account, allowed readers to partake of the traveler's firsthand experience of exotic cultures and designs. A fine example is a four-volume guide to France entitled *Topographia Galliae* (Topography of Gaul) (1655–61), by Martin Zeiller (1589–1661) (fig. 35). Zeiller, an Austrian teacher, historian, geographer,

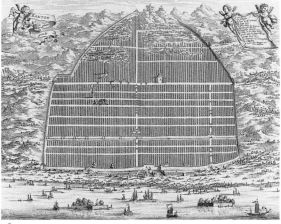

36

35

Hand-colored etching and
engraving of aerial plan of Paris,
1620. Volume I from *Topographia
Galliae*, by Martin Zeiller. 21 × 31 cm.
Frankfurt: Caspari Meriani, 1655–61

36

Engraving depicting the plan of the
city of Canton, China, from *Het
gezantschap der Neêrlandtsche
Oost-Indische Compagnie*, by
Johannes Nieuhof. 25 × 39 cm.
Amsterdam: Jacob van Mears, 1665

and surveyor, traveled throughout Europe recording his observations and
making illustrations of cities, villages, landscapes, and buildings. Zeiller's
eighteen-part series, *Topographic* (Topography), which consisted of his
images and descriptions of Germany, Switzerland, France, Eastern
Europe, and Greece, was published from 1649 through 1665. *Topographia
Galliae*, the fifteenth part of the series, was dedicated to King Louis XIV
and contains more than three hundred hand-colored engravings and
maps. After an introductory history of France, Zeiller describes in detail
the gardens, plazas, roads, cities, palaces, bridges, farms, and countryside
of the kingdom's thirteen provinces. Zeiller's commentary, along with his
copious images, offers us a comprehensive picture of the country as well
as an understanding of day-to-day life and travel in the seventeenth century.

Much as with illustrated books on natural history and archaeology, early
exploration accounts were prime sources of ornamental patterns.
European craftsmen and designers were avid for information on the
Orient and regularly perused these travel books for inspiration. Johann
Nieuhof (1618–1672), an agent for the Dutch East India Company in
China, published a book on his return to Holland entitled *Het gezantschap
der Neêrlandtsche Oost-Indische Compagnie* (The embassy of the Dutch East
Indies Company) (1665) (fig. 36). It became an immensely popular source
for designers because the illustrations and descriptions of Chinese
objects, furniture, gardens, and buildings were so clear, detailed, and
accurate. German and French editions quickly appeared. More than fifty
years later, the Viennese architect and historian Fischer von Erlach based
the oriental design section in his encyclopedia, *Entwurff einer historischen
Architectur* (A plan of civil and historical architecture) (1725), primarily on
Nieuhof's book.

All the illustrated books and journals discussed in this chapter—on
etiquette, status, home management, events, propaganda, and travel—
document the taste, day-to-day activities, rituals, and social structures of
particular eras. Though seemingly diverse in content and purpose, each
item contributes to our understanding of a society as well as its need—
and desire—to create decorative objects. These books and journals both
inspired designers and illuminated the nature of the world in which these
practitioners lived and worked. For us, they comprise an important
resource that links the creation and use of objects to the societies that
originated, regulated, and encouraged their production.

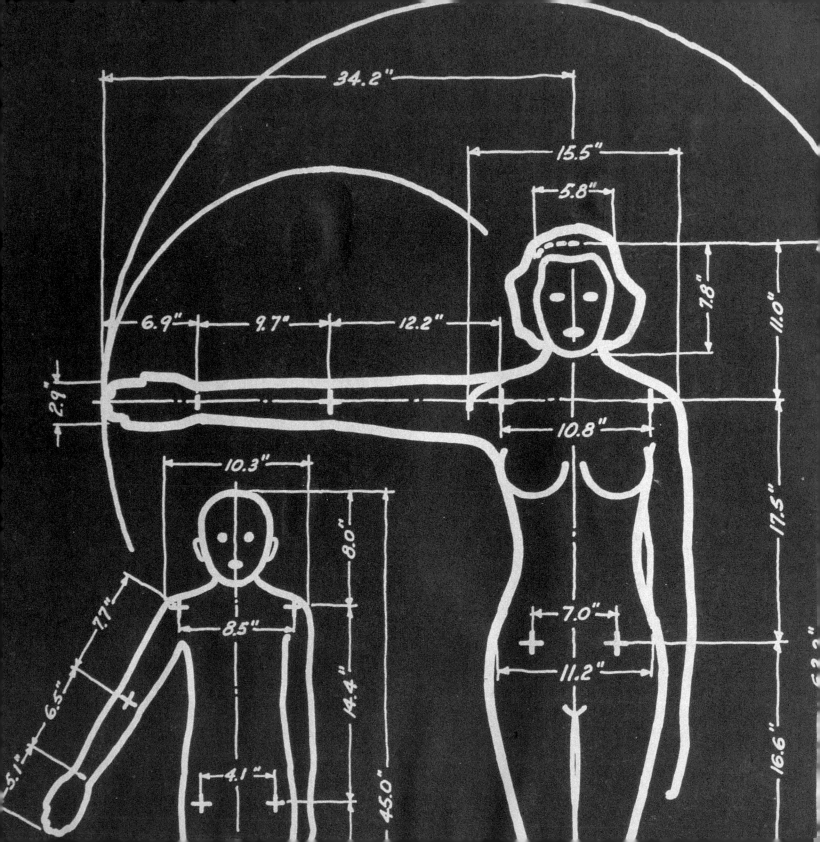

Design Instruction

To understand the history of design and the decorative arts, we must examine the procedures and materials used in their manufacture. Initially, this information was passed down orally from generation to generation, usually from father to son or from master to apprentice. As civilization grew more complex and processes began to be standardized, the oral tradition gave way to written instructions. However, these instructions continued to be treated, as they had been in the oral tradition, as "trade secrets." But the industries that started to develop in the eighteenth century required more efficient and regulated means of production. As a result, illustrated instruction manuals eventually became a primary means of widely—and publicly—communicating information about the latest styles and materials, as well as about new methods of production. Concurrently, guides of varying levels of expertise were also being created for the homeowner and amateur hobbyist; among the topics they covered were carpentry, sewing, decorating techniques, and gardening.

Technical Encyclopedias

From antiquity through the early Renaissance, hard-working scribes produced guides to fields such as painting, drawing, glassmaking, enameling, metalwork, and architecture. Beginning in the fifteenth century, these manuscripts were rediscovered, translated, revised, and then published. At the same time, craftsmen continued the oral tradition of imparting "trade secrets" only to their apprentices. It is within this environment that the French art critic and philosopher Denis Diderot (1713–1784) published his groundbreaking *Encyclopédie, ou, Dictionnaire raisonné des sciences, des arts et des métiers* (Complete encyclopedia or dictionary of science, arts, and crafts) (1751–65), which described and illustrated most of these very same trade secrets (fig. 37).

Opposite

Detail of figure 42

For his *Encyclopédie,* Diderot compiled seventeen volumes of text and eleven volumes of plates. His goal was to create, for the benefit of future generations, an illustrated account of trade processes that had not been recorded previously. The task was formidable. Diderot spent years ferreting out these trade secrets. He constantly faced the threat of censorship and, at times, even imprisonment, because the guilds regarded his efforts as a threat to their existence. Critics leaped on the initial volumes of the *Encyclopédie,* accusing Diderot of undermining the society's economic structure. Ironically, these sensational disputes only enhanced the publication's popularity and sales, much as they might do today. The first volume garnered more than two thousand subscribers (making it a bestseller in an era when only 15 percent of the population could read) and this enthusiasm continued for the entire twenty-eight volumes.

The *Encyclopédie* is filled with descriptions and illustrations of eighteenth-century technical processes used in trades such as metalwork, papermaking, upholstering, glassmaking, and ceramics. The detailed engravings often depict craftsmen performing their tasks step by step, along with their tools, equipment, and raw materials. Diderot not only chronicles and standardizes these contemporary trade procedures, but also gives us a comprehensive view of the pre-industrialized manufacturing world of eighteenth-century France.

Inspired by the success of the *Encyclopédie,* the Royal Academy of Science embarked on an even more extensive illustrated survey of French crafts entitled *Description des arts et métiers* (Description of arts and crafts) (1761–89). Consisting of 113 volumes, *Description* covers more than 70 crafts. Because each volume contains lengthy essays written by specialists, *Description* is far more accurate and detailed than Diderot's *Encyclopédie.* The Library collection contains 14 of the 113 volumes, with the text and its illustrations bound together in each volume.

While comprehensive trade encyclopedias formalized methods of creating objects, they also established a base from which new methods of production could be developed when the industrial revolution took off in the nineteenth century. The new industrial age required its citizens to understand manufacturing processes. One way of ensuring this happened was to instruct children in manufacturing basics. *Galerie industrielle* (1825), a simplified version of Didierot's *Encyclopédie,* was created for this purpose (fig. 38). Containing more than a hundred hand-colored engravings, the book describes and illustrates procedures for making bread, hats, wine, sugar, cloth, glass, metal objects, furniture, and paper.

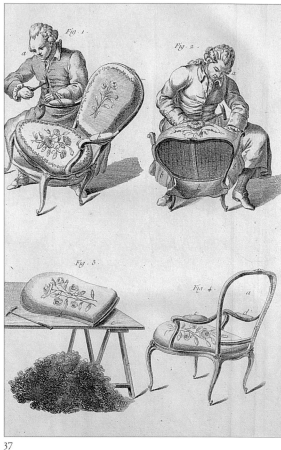

37

38

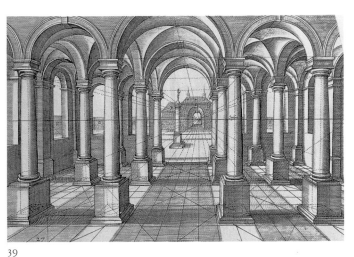

39

37

Engraving depicting the craft of
upholstery in "Tapissier," volume 9,
plate 9, from *Encyclopédie, ou,
Dictionnaire raisonné des sciences, des
arts et des métiers*, by Denis Diderot.
26 × 40 cm. Paris, 1751–65

38

Hand-colored engraving depicting
the making of pottery and bricks.
Page 106 from *Galerie industrielle*.
26 × 19 cm. Second edition, Paris:
A. Eymery, 1825

39

Engraving illustrating the theory of
one-point perspective, by Hendrick
Hondius (b. 1573). Plate 27 from
Perspective, by Hans Vredeman de
Vries. 38 × 30 cm. The Hague, 1615

Guides to Design Elements

In addition to encyclopedias, the Library contains specialized manuals on
how to use a particular material, manufacture a product, or acquire a skill.
Some treatises deal with basic design elements such as drawing and
color; others cover specific topics such as graphic design, interiors, archi-
tecture, glassmaking, cabinetry, and textiles.

Several Renaissance guides on drawing techniques and theories of
perspective became standard tools for artists, architects, and craftsmen.
Hans Vredeman de Vries (c. 1527–1604), a Dutch ornamentalist and
painter, created a guide entitled, *Perspective* (1615), about the theory of
perspective and the proper use of vanishing points in drawing (fig. 39).
Intended for artisans, carpenters, designers, "and all lovers of the arts,"
the book includes seventy-three engravings with perspective lines placed
over abstract geometric shapes, cityscapes and buildings, and interiors
and courtyards. *Perspective*, together with de Vries' guides on other sub-
jects, such as drawing, landscape design, mathematics, and architecture,
exerted a significant influence on northern European design. Dutch painter
Jan Vermeer (1632–1675), who frequently consulted guides on perspec-
tive and drawing, is said to have had a copy of *Perspective* in his library. De
Vries' guides continued to be reissued well into the nineteenth century.

Artists, painters, and craftsmen also regularly used manuals on tech-
niques of figure drawing, methods of mixing and applying colors, and
printing processes such as engraving and etching. One early example is
Ars pictoria, or, An academy treating of drawing, painting, limning, etching

(1675), by British royal portraitist Alexander Browne (active 1660–1683) (fig. 40). *Ars pictoria* contains more than thirty etchings of the human form inspired by Anthony Van Dyck's paintings and old master prints. Browne's drawing manuals, together with his later print reproductions of paintings, both inspired artisans and craftsmen and helped establish standard procedures in painting and modeling for generations.

Besides providing guides to proper scale and drawing methods, instructional manuals reported on the latest scientific and aesthetic theories about color, new synthetic dyes and paints, and the accepted methods for the mixture and application of pigments to paintings and objects. French chemist Michel Eugène Chevreul (1786–1889) was one of the first theorists to study the psychological effects of color. As director of the dye-works at the Gobelins tapestry factory during the 1820s, he noticed that weavers perceived colors situated next to each other differently from colors viewed in isolation. He also discovered that the tone and hue of any two appear to change when they are placed side by side, an effect he called "simultaneous contrast." He first published his observations in *De la loi du contraste simultané des couleurs* (The principles of harmony and contrast of colors) (1839), which has more than thirty hand-colored charts showing hues and tones in various arrangements on contrasting backgrounds (fig. 41). Chevreul's studies on color, contrast, and figure-foreground effects were widely referenced by artists in the later part of the nineteenth century, particularly pointillists such as Georges Seurat and Paul Signac, who experimented with his color theories in their paintings.

In the twentieth century, industrial designers such as Henry Dreyfuss (1904–1972) developed manuals that, like earlier guides, promoted certain theories and outlined procedures that could easily be adapted. Dreyfuss incorporated ergonomics (the study and use of human dimensions in the design process) in the products he chronicled in his book, *Designing for people* (1955) (fig. 42). This book included human factor charts, drawn by engineer Alvin Tilley, that specified average body measurements for male and female adults and children. Dreyfuss's *The measure of man* (1960), a more comprehensive manual on ergonomics than *Designing for people,* contained life-size, folded up human factor charts as well as other information on anthropometrics for product and furniture designers to use.

Technical Manuals

In addition to basic design guides, numerous books also outlined methods of creating specific products—glass, metalwork, paper, and buildings, to name just a few. Some guides recorded methods devised in past eras; others

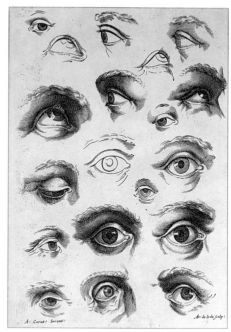

40

40

Engraving of artist's studies depicting the eye. Plate 2 from *Ars pictoria, or, An academy treating of drawing, painting, limning, etching,* by Alexander Browne.
21 × 32 cm. London, 1675

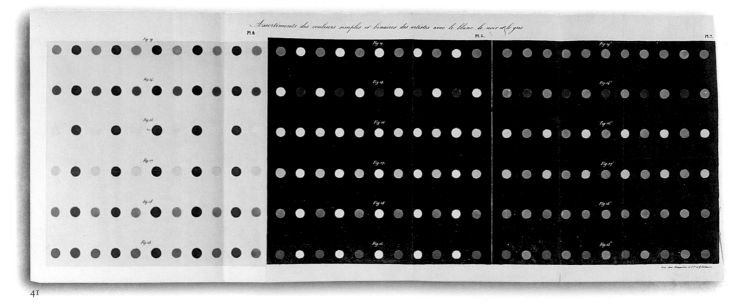

41

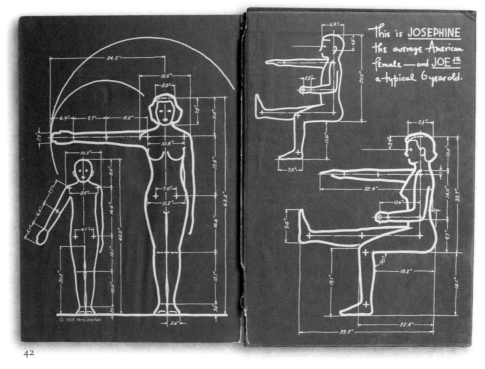

42

41

Hand-colored engraving of color studies. Plates 5–7 from *De la loi du contraste simultané des couleurs*, by Michel Eugène Chevreul. 22 × 28 cm. Paris: Pitois-Levrault et cie, 1839

42

Photomechanical reproduction of ergonomic charts depicting "Josephine & Joe Jr." Endpaper from *Designing for people*, by Henry Dreyfuss. 17.5 × 25 cm. New York: Simon and Schuster, 1955

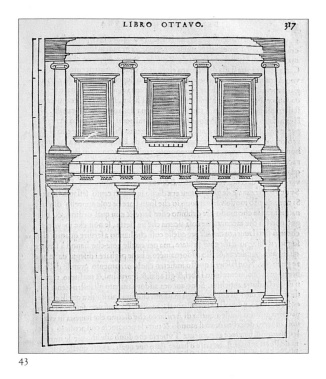

43

43

Woodcut depicting an elevation of a two-story building. Page 317 from *L'architettura*, by Leon Battista Alberti. 23 × 35 cm. Florence: T. Torrentino, 1550

44

Engraving of a design for a solar-powered fountain. Page 15 from *Les raisons des forces mouvantes avec diverses machines tant utilles que plaisantes*, by Salomon de Caus. 26.5 × 41 cm. Frankfurt: I. Norton, 1615

promoted the latest styles, technologies, and materials. Their audiences ranged from the accomplished professional to the hobbyist. However, most of these books were aimed at practicing technicians and artisans. As a result, they frequently became the foundation stones for industries such as glassmaking, building, and papermaking.

L'architettura (Architecture) (1550), the initial Italian-language translation of *De re aedifiactoria* (On the art of building) (1485), written in Latin by Leon Battista Alberti (1404–1472), an Italian artist, theorist, and architect, was the first printed architecture book that was based on Vitruvius's *De architectura* (c. 20 B.C.) (fig. 43). Alberti, like Vitruvius, divides his book into ten parts and focuses on the function, design, and structure of architectural projects. Because Alberti had studied both ancient sites and contemporary building practices, he was able to greatly expand on Vitruvius's work. He created a consistent, comprehensive, and historically accurate guide to construction techniques, building types, and design elements such as proportion, symmetry, and ornament. His manual became the very first standard architecture and construction guide, one that could be effectively used or adapted by all builders and designers.

44

In like manner, illustrated engineering manuals were created to standardize procedures for building canals, aqueducts, fountains, and bridges. Salomon de Caus (1576–1626), a French engineer and designer of gardens and grottos throughout Europe, wrote a remarkable hydraulics manual entitled *Les raisons des forces mouvantes* (Principles of moving forces) (1615) (fig. 44). Like Alberti, Caus first studied treatises from classical antiquity in preparation for developing his engineering inventions and hydraulic systems. *Les raisons* contains more than thirty illustrations and descriptions of the methods of and the equipment needed for moving and raising water, including examples that employ solar, pump, and waterwheel systems. Also featured are plans and descriptions of hydraulic projects designed and executed by Caus.

Similar technical manuals were published containing both plans for parks and private gardens and the procedures for realizing them. *La theorie et la pratique du jardinage* (The theory and practice of gardening) (1722) by Antoine-Joseph Dézaillier d'Argenville (1680–1765), originally published in 1709, analyzes the formal garden (which in France was at its height of popularity during the late seventeenth and eighteenth centuries)

and offers practical guidance for its creation (fig. 45). Containing more than fifty diagrams and plans, *Theorie* advocates architectural topiary—the sculpting of plants, shrubs, and hedges with shears—as an element in garden design. It also offers a host of new patterns for borders, labyrinths, and garden rooms. Dézaillier d'Argenville, a writer and art collector, traveled throughout Italy and France studying natural history and garden patterns, and drawing and gathering information in preparation for this guide. *Theorie,* with four editions published between 1709 and 1747, brought Dézaillier d'Argenville such acclaim that he was asked to contribute articles on hydraulics and gardening to Diderot's *Encyclopédie.*

Around this time, Jacques-François Blondel (1705–1774), a French architect and teacher, wrote a comprehensive manual on the planning and construction of buildings, gardens, and interiors (both public and private) entitled *De la distribution des maisons de plaisance* (About the arrangement of country cottages) (1737–38) (fig. 46). As with Dézallier d'Argenville's *Theorie,* Blondel's work provides useful descriptive procedures along with illustrations to assist artisans in designing and constructing buildings and gardens in the French style. Particularly significant is his focus on three elements—layout, placement of objects within rooms, and the ornamentation of interiors—to create a pleasing balance between a space's aesthetics and its function. This careful focus makes his work one of the earliest practical guides to interior design.

An equally significant early manual, aimed at trained technicians, is a compilation of seven books on glassmaking, *L' Arte vetraria* (The art of

45

Engraving of designs for sculpted garden hedges. Pages 62–63 from *La theorie et la pratique du jardinage,* by Antoine-Joseph Dézaillier d'Argenville. 20.5 × 26 cm. Nouvelle edition, Paris: Jean Mariette, 1722

46

Engraving of a French salon interior with chimney. Volume 2, plate 81, from *De la distribution des maisons de plaisance, et de la décoration des edifices en général,* by Jacques-François Blondel. 23 × 29 cm. Paris: C. A. Jombert, 1737–38

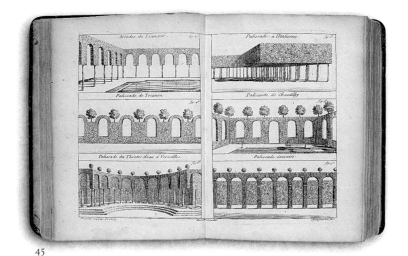

45

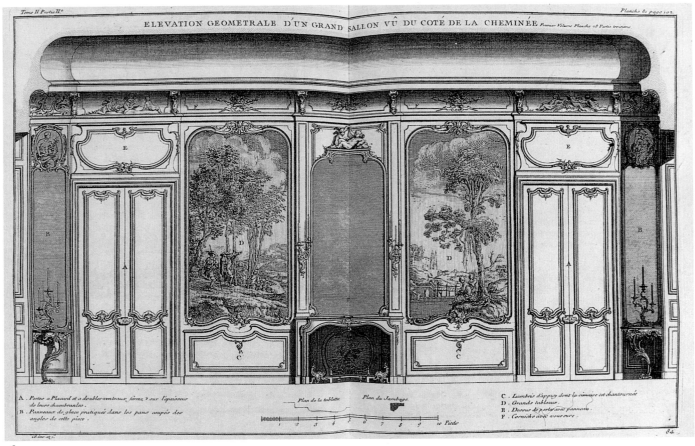

46

glass) (1612), by Antonio Neri (d. 1614). In it, Neri, a Florentine priest, glassmaker, and chemist, outlines the basic principles for Italian glassmaking, including the use of furnace fuels, how to make colored glass, and glass formulas involving the use of metals such as copper and lead. One of the earliest works to record such basic techniques, *L' Arte vetraria* was highly influential, spreading new and traditional information on this craft throughout Europe. A later French edition, entitled *Art de la verrerie* (1752) (fig. 47), includes additional essays on precious stones and porcelain by two other writers.

Technicians also craved information on the art of metalsmithing, used to manufacture tools, weapons, utensils, architectural ornament, and eclesiastical and decorative objects. *Art des forges et fourneaux à fer* (The art of smithies and iron works) (c. 1761–62) by Gaspard Le Compasseur de

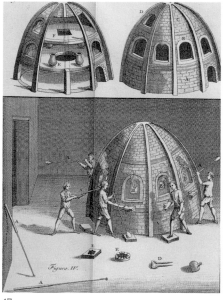

47

47

Engraving of furnaces and glassblowing. Figure 4 from *Art de la verrerie*, by Antonio Neri. 20.5 × 26 cm. Paris: Durand, 1752

48

Engraving depicting the forging for cast iron from *Art des forges et fourneaux à fer*, by Gaspard Le Compasseur de Créqui-Montfort de Courtivron. 28.5 × 37 cm. Paris, c. 1762

Créqui-Montfort de Courtivron (1715–1785), one of the earliest parts of the *Descriptions des arts et métiers* (a multivolume series discussed earlier in this chapter), provides detailed descriptions and illustrations of the equipment and processes for making both wrought and cast iron (fig. 48). Despite dealing with both types of iron, the treatise's main significance lies in its being one of the earliest guides to the manufacture of cast iron. Because it was made with iron ore byproducts and coke, cast iron could be produced more cheaply than wrought iron. Guides such as *Art des forges* became even more important as the demand for cast iron increased and as the craft itself evolved into a large industry in the later part of the eighteenth century.

The *Descriptions des arts et métiers* series also includes a guide to the tools and processes for making paper in eighteenth-century Europe. As with metalsmithing, the field of papermaking grew significantly in the nineteenth century. The improved machinery and technology used in paper production required higher levels of training for workers and consequently more sophisticated manuals. As Europe entered the twentieth century, the manufacture of decorated or marbled papers, frequently used as endpapers in books, also became more mechanized. *Buntpapierfabrikation* (c. 1910), by August Weichelt (1840–1911), is a beautifully illustrated manual and sample book that describes procedures for making

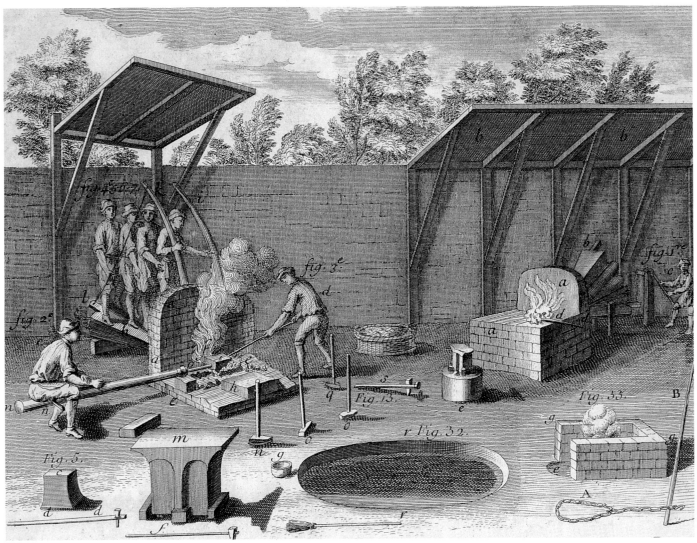

48

49

50

machine-processed colored and marbled papers (fig. 49). In it, Weichelt enumerates the tools, dyes or paint, and equipment for the production of more than one hundred paper patterns.

In the twentieth century, manuals were created to assist graphic and industrial designers in designing and promoting products. *Catalog design* (1944), by Knud Lönberg-Holm (1895–1972) and Ladislav Sutnar (1897–1976), for example, is one of the first guides intended to help establish standards for creating catalogs that would illustrate, describe, and market industrial equipment (fig. 50). Lönberg-Holm was the research director and Sutnar the art director for the F. W. Dodge Corporation's Sweet's catalog service—the largest producer of trade, product, and manufacturing catalogs in the United States. After a study of their own and others' catalogs, the two men determined that to be effective, catalogs should be standardized by function, content, and format. They should also contain clear "visual units," striking covers, and simple indices. *Catalog design*, with its case studies and examples of Lönberg-Holm and Sutnar catalog designs, remains both a useful primer and a comprehensive document of the two men's work.

49

Marbled paper samples. Numbers 179–84 from *Buntpapier-fabrikation*, by August Weichelt. 16.5 × 24 cm. Berlin: C. Hoffmann, c. 1910

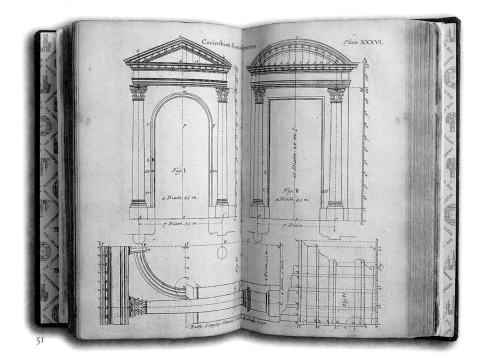

51

50

Photomechanical reproduction of
color illustrations of catalog covers.
From *Catalog design*, by Knud
Lönberg-Holm and Ladislav Sutnar.
16 × 21 cm. New York: Sweet's
catalog service, 1944

51

Engraving of designs for doorways
with Corinthian columns. Plate 36
from *The builder's complete assistant*,
by Batty Langley. 15.5 × 24 cm.
Fourth edition, London: I. and J.
Taylor, 1738

Craftsmen's Guides

In addition to manuals directed at skilled technicians, guides were created
with basic instruction on crafts such as embroidery, furniture making and
finishing, interior decoration, and smaller building projects. Generally
intended for small craft industries, these guides also spread useful tech-
niques and styles throughout Europe and America.

One extremely popular manual for workmen, dealing with carpentry
and architectural drawing techniques, was *The builder's complete assistant*
(4th edition, 1738), by Batty Langley (1696–1751) (fig. 51). Langley, an
English architect, writer, and teacher, also wrote manuals on masonry,
building restoration, bridge construction, garden planning, mathematics,
and surveying. His basic guides to carpentry and masonry—including
The builder's complete assistant, *A sure guide to builders* (1729) and *The
young builder's rudiments* (1730)—contain hundreds of measured drawings
for windows, doors, ceilings, and other architectural details that carpenters
could readily copy and then adapt for a variety of building projects.

In a similar way, Asher Benjamin (1771–1845), an American writer and
architect, published a number of "how-to" books from 1799 to 1830 that

became the major source of designs for builders and craftsmen in the United States during the nineteenth century. He took some of the patterns in his books directly from renowned English architects such as Inigo Jones (1573–1652) and William Chambers (1726–1796). Benjamin's main contribution, however, was adapting contemporary styles to suit the pocketbooks of would-be patrons and the skills of local craftsmen. *The American builder's companion* (5th edition, 1826) includes descriptions and plans for more than fifty projects, among them a townhouse; churches; the installation of rafters, doors, and windows; architectural detailing; and the construction of spiral staircases (fig. 52). Benjamin's manuals frequently promoted neoclassical style. Not surprisingly, that style was used for many buildings throughout the United States during the nineteenth century.

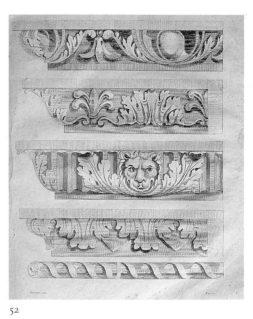

52

Also around this time, guides on textile manufacturing and cloth decoration provided basic instruction as well as introduced new techniques and patterns. August Netto (active late eighteenth to early nineteenth century), a German teacher and writer, wrote a series of manuals published from 1798 to 1808 on knitting, sleeve patterns, sewing techniques, and embroidery. His *L'art de tricoter* (The art of knitting) (1802) offers detailed instruction and more than fifty diagrams for embroidery and knitting projects (fig. 53). Patterns for items such as decorative banners and clothing are depicted in various stages of completion on large-scale grids that resemble the actual weave of the cloth. Netto also includes useful information about fibers and knitting and embroidery tools.

Guides to materials such as fabrics, metals, clays, papers, and wood were important resources for architects, craftsmen, and designers. One beautiful dictionary entitled *Icones lignorum exoticorum et nostratium Germanicorum* (Engraved illustrations of exotic and native woods) (1773–78), by Jan Christiaan Sepp (1739–1811), both describes and illustrates the colors, grains, and properties of wood (fig. 54). To put together this dictionary, Sepp, a Dutch painter and engraver, examined and recorded the grains and hues of more than five hundred species of trees from around the world. In addition to its hand-colored engravings, the dictionary includes the name and a brief description of each specimen in five languages. The detailed and accurate renderings of each wood grain, together with the comprehensive index, make this a valuable resource for craftsman and furniture historians even today.

Many practical guides to upholstering, constructing, embellishing, and finishing furniture, originally aimed at nineteenth-century craftsmen, have become useful resources for modern restorers, historians, and

52

Engraving of designs for decorative moldings. Plate 23 from *The American builder's companion*, by Asher Benjamin. 22 × 27 cm. Fifth edition, Boston: R. P. & C. Williams, 1826

53

Hand-colored etching of an embroidery pattern. Number 23 from *L'art de tricoter*, by August Netto. 45 × 30 cm. Leipzig: Vosset et compagnie, 1802

54

Hand-colored engravings depicting wood grain patterns. Table 6 from *Icones lignorum exoticorum et nostratium Germanicorum*, by Jan Christian Sepp. 23.5 × 31 cm. Nürnberg, 1773–78

53

54

FRENCH DOME BED.

A. The Plan of Canopy and Dome.
B. Plan of Teaster.
C. Plan of Bedstead.

Scale for Plan.

55

woodworkers. Two remarkable examples are *The cabinet-maker and uphol-
sterer's guide* (1826) (fig. 55), by George Smith (active nineteenth century),
and *The decorative painters' and glaziers' guide* (1828) (fig. 56), by Nathaniel
Whittock (active nineteenth century). In his manual, Smith, upholsterer
and furniture maker to Britain's King George IV, offers drawings and
detailed instructions for designing more than a hundred household
items, including lighting, room interiors, window treatments, and furni-
ture. Useful tips on drawing, perspective, fabric treatment, use of colors,
and ornamentation in styles ranging from the neoclassical to the
arabesque are also included.

 The cabinet-maker enjoys some overlap with Whittock's *The decorative
painters'*, particularly in the discussion of drawing and ornament.
However, *The decorative painters'* focuses more on techniques, equipment,
and patterns for finishing, painting, and decorating rooms and furniture

56

than on construction methods, as Smith's book does. As a result, the two works nicely complement each other. Whittock, an English lithographer, writer, and teacher, also includes in his book a section on the manufacture, coloring, and design of stained glass. Most significant for both the furniture historian and refinisher, however, is Whittock's discussion of paints, stains, and varnishes, along with the tools and methods used for creating a variety of graining patterns on wood.

Manuals for the Amateur

In addition to guides specifically for manufacturers and technicians, manuals were also created for nonprofessionals who wished to learn or expand their knowledge of a craft, home industry, or pastime. These do-it-yourself books grew in popularity, particularly in the nineteenth century, as an emerging literate middle class had more leisure time for hobbies, domestic life, and home projects. However, several notable amateur guides were published even in earlier centuries. One of these is *A treatise on japaning and varnishing* (1688), by John Stalker (active seventeenth century) and George Parker (active seventeenth century), a beautifully illustrated manual on the art of japanning furniture and other objects (fig. 57). It was meant to be used by both professional craftsmen and elite "young ladies" seeking a pastime. The book was created to provide a less expensive alternative to the rare and expensive lacquered items then being brought back to Europe by travelers to the Far East, which were in great demand. It offers basic technical advice on varnishing methods, gilding, decorative graining, and the preparation of pigments. Twenty-four engravings depict chinoiserie-style patterns of buildings, figures, plants, and birds; many of these patterns were inspired by Johann Nieuhof's 1665 guide to China (see chapter 2). The craze for lacquerware continued throughout the eighteenth century, resulting in more elaborate guides, such as the popular *The Ladies amusement; or, Whole art of japanning made easy* (1762), which features more than one hundred motifs drawn from Chinese and Japanese patterns.

Manuals promoting smaller craft industries, such as Alexander Paul's (active nineteenth century) *The practical ostrich feather dyer* (1888), were also popular in the nineteenth century (fig. 58). Like Stalker and Parker, Paul gives practical advice on how to produce a highly desired item—in this case, colorful ostrich feathers, then principally used to adorn clothing, hats, and other fashion accessories. This handy guide, geared not to trained chemists but rather to those with "good practical common sense

Engraving of patterns used to decorate brushes. Plate 4 from *A treatise of japaning and varnishing*, by John Stalker and George Parker. 24 × 38 cm. Oxford, 1688

Samples of ostrich feathers. Page 64A from *The practical ostrich feather dyer*, by Alexander Paul. 14.5 × 18 cm. Philadelphia: Mrs. Dr. M. Frank, 1888

Cloth Brushes

Combs Brushes

57

NAVY BLUE—page 31.

MAGENTA—page 69.

PEA GREEN—page 80.

BRONZE—page 74.

58

and judgement," offers useful information on how to set up a work area and buy equipment and supplies, along with recipes for dyeing the feathers in more than twenty shades. The book is full of examples of actual dyed feathers, in colors such as "steel," "corn," "cardinal," and "sea foam."

Do-it-yourself manuals and publications dealing with home projects or learning a hobby were produced in great numbers in the late nineteenth century and on into the twentieth century, particularly in the areas of interior decoration, sewing, woodworking and cabinetry, and gardening. Though varied in size and focus, these guides provided basic instruction, helpful tips to enhance the process, and resources for additional study. *The lady's manual of fancy work* (1859), by Mrs. Matilda Marian Chesney Pullan (active nineteenth century), is a good example of a comprehensive manual of crocheting, embroidery, lace making, appliqué, and other sewing techniques aimed at both the novice and the seasoned craftsperson (fig. 59). In this work, Mrs. Pullan, who was also a contributor to many popular magazines, offers useful advice on

equipment and fabrics, along with illustrated procedures for more than forty sewing projects.

In addition to self-instruction manuals for adults, the nineteenth century saw the creation of book series for teaching children the basics of penmanship, mathematics, and reading. Walter Crane (1845–1915), a British designer and illustrator, produced more than fifty picture books for children, several of them written to assist young readers in learning the alphabet. He created *A romance of the three Rs* (1886), a series of stories about a boy's adventures in learning handwriting, specifically to instruct his son Lionel (fig. 60). Crane's beautifully illustrated storybooks and primers entertained while they also taught basic reading and penmanship skills to generations of children.

All these manuals, ranging from alphabet primers to technical encyclopedias, provide us with important insights into the materials, processes, tools, and methods of instruction employed in the creation of decorative objects in particular eras. And, like the books of Walter Crane, many are valued as artifacts of design themselves. As design resources, these

59

Color engraving of fancy needlework patterns. Plate 2 from *The lady's manual of fancy work*, by Mrs. Matilda Marian Chesney Pullan. 14 × 21 cm. New York: Dick & Fitzgerald, 1859

60

Photomechanical reproduction of color lithograph from *Pothooks & perseverance or A.B.C. Serpent*, compiled in *A romance of the three Rs*, by Walter Crane. 22.5 × 23 cm. London: Marcus Ward & Co., 1886

60

guides disseminated both technical knowledge and ornamental styles throughout the world. They recorded and standardized processes and, at the same time, provided the base from which new formulas and technological advances emerged. These manuals also document the history of technology from the days of the medieval guilds to the era of mass production, as well as the social and economic forces that effected these changes—so that, today, they are invaluable resources for both historians and restorers.

No. 4
THE PITTSBURGH HOUSE OF GLASS

Sponsored by

Pittsburgh Plate Glass Company

Pittsburgh Corning Corporation

Crane Co.
Fir Door Institute
General Electric Company
Johnson Wax Products
Nash Motors Division—Nash-Kelvinator Corporation
National Better Light-Better Sight Bureau
New York Telephone Company

Furnishings by Modernage

A G-E ALL ELECTRIC HOUSE

Architects: Landefeld & Hatch,
152 West 42nd Street, New York, N. Y.

FIRST FLOOR PLAN

SECOND FLOOR PLAN

NEW YORK WORLD'S FAIR 1939

Documenting Design

The resources we have examined so far, though varying in scope and purpose, together provide a foundation for this chapter's examination of some of the core titles that document styles and movements in the history of design and decorative arts over the past centuries. These include works chronicling variant styles of both handmade and mass-produced objects, as well as trade catalogs and historic surveys.

Books illustrating different styles, used as guides for constructing or embellishing objects ranging from delicate seventeenth-century lace to twentieth-century suburban houses, have always been essential in the study of design. Trade catalogs, whose main purpose was to display items for sale, now provide us data on the existence and marketing of decorative and functional objects. Surveys, serials, exhibition catalogs, and personal narratives by designers and historians shed light on major movements, trends, and designers of various era. They also reveal the interplay between the fine and applied arts which, in many periods, were closely related.

A major *general* design resource is *Repository of arts, literature, commerce, manufactures, fashions, and politics* (1809–15), a monthly periodical edited and published by Rudolph Ackermann (1764–1834). It is one of the great serials dealing with early nineteenth-century English taste, culture, and design (fig. 61). An enterprising publisher and designer, Ackermann established the Repository of Arts, which consisted of the periodical; an art school; a store that sold prints, art supplies, and books; and a chemistry lab that manufactured paints. *Repository* contained articles aimed at women on topics such as interior design, furniture styles, clothing, ornament, architecture, and gardens. Each issue featured six hand-colored "embellishments" illustrating patterns, fashions, and buildings, and also included swatches of printed and woven fabrics. Today, the *Repository*'s nearly 1,500 colored engravings and hundreds of textile samples, along

Opposite

Detail of figure 85

61

Engraving of title page with fabric samples. Volume 3, February 1810, from the *Repository of arts, literature, commerce, manufactures, fashions, and politics*, edited and published by Rudolph Ackermann. 15 × 25 cm. London, 1809–15

62

Photographs of French art deco jewelry from *Paul Templier et Fils, joailliers-fabricants*. 18.5 × 25 cm. Paris, c. 1927

62

with the accompanying commentary, are a rich primary source for
designers, preservationists, and historians.

The other works in the Library collection we will examine concentrate
on specific types and areas of design.

Personal Adornment: Jewelry and Textiles
The Library contains a number of works on the history of jewelry and
other personal artifacts such as matchsafes, cigarette lighters, fans,
purses, and snuffboxes. One beautiful example is *Paul Templier et Fils,
joailliers-fabricants* (Paul Templier and son, jewelers-manufacturers)
(1927), a trade catalog issued by the Templier Company (fig. 62). To com-
memorate Charles Lindbergh's transatlantic flight of May 1927, images of
machinelike jewelry for men are superimposed on a photograph of an
airplane. In contrast, women's jewelry is displayed in a more muted
manner on female models. With illustrations of more than twenty art
deco–style items, the catalog creatively uses photo overlays to emphasize
the technological modern age and, at the same time, provides an example
of old-fashioned gender-based marketing techniques.

Surveys, design manuals, and commercial catalogs dealing with printed
and woven textiles chronicle the development, patterns, and use of fabrics
(wool, linen, synthetics, cotton, and silk) as well as techniques for making
them (weaving, knitting, embroidery, and lacework). One such book,

63

64a

64b

produced by Matteo Florimi (active sixteenth century), is entitled *Fiori di ricami nuouamente posti in luce* (The best of embroidery designs recently brought to light) (1603) (fig. 63). Consisting of twenty-four woodcuts of needlework lace patterns featuring flowers, birds, and human and animal figures, the book includes designs by well-known "lacemasters" such as Giovanni Battista Ciotti and Cesare Vecellio. Florimi, an engraver and publisher, issued numerous lace pattern books—many expressly created to be copied by upper-class ladies. Today they serve as a record of late sixteenth-century styles and the patterns of some of the era's prominent designers.

More than a century and a half later, J. Forbes Watson (1827–1892), a writer and director of the India Museum in London, compiled a twenty-volume set of textile samples entitled *Collection of specimens and illustrations of the textile manufactures of India* (second series, 1873–77) (fig. 64a, 64b). The set consists of more than 1,120 samples of colorful woolen, silk, and cotton fabrics from "India," an area comprising current-day India, Pakistan, Nepal, Afghanistan, and Bangladesh, that Watson amassed from the surplus textile collections of the India Museum. With an eye to stimulating trade between England and India, Watson noted the fabric's price, weight, and place of manufacture on each sample card. *Collection of specimens*, and a later color photolithograph version of it, became a popular source of non-Western patterns for students and designers throughout England. Even today, these fabrics' vibrantly exotic and bold designs continue to inspire fashion and textile designers.

63

Woodcut of lace needlework pattern fom *Fiori di ricami nuouamente posti in luce*, printed by Matteo Florimi. 20 × 15 cm. Siena, 1603

64a and 64b

Silk fabric samples. Numbers 540 and 536, second series, from *Collection of specimens and illustrations of the textile manufactures of India*, compiled by J. Forbes Watson. 22 × 35 cm. London: India Museum, 1873–77

65

Portfolio with fabric samples and color studies from *Texture*, by Makiko Minagawa. 26.5 × 39 cm. Tokyo: Kodansha, 1988

In the twentieth century, textile sample books of particular designers' works help to spread new technologies and patterns worldwide. *Texture* (1988), devoted to the work of Japanese textile designer Makiko Minagawa (active twentieth century), includes within its silk-covered slipcase a book of commentary and photographs, a portfolio of more than a hundred color variations for fabrics, and more than sixty fabric samples (fig. 65). Since 1970, Minagawa has created fabrics exclusively for fashion designer Issey Miyake, utilizing a range of weaving techniques, fibers, and finishing processes to develop colorful, textured textiles. The essays by fellow designers and the artist provide an insight into Minagawa's innovative design philosophy, patterns, and processes.

Tableware: Ceramics, Glass, and Silverware

Publications on dinnerware, ceramics, glass, and cutlery illustrate objects that adorn or are used in the home. They provide us with information about the tableware used by a culture in a particular era. A pattern book

65

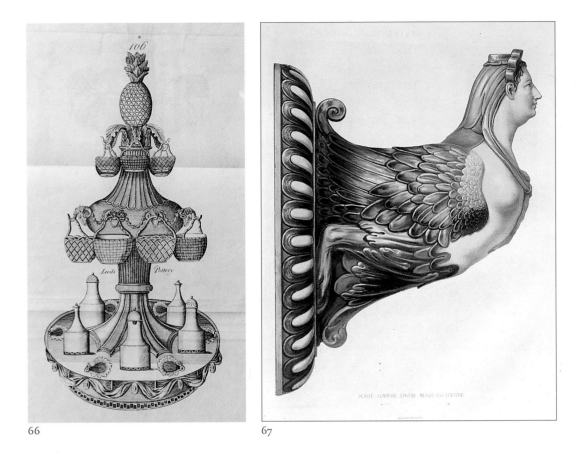

66

67

entitled *Designs of sundry articles of queen's or cream-colour'd earthen-ware manufactured by Hartley, Greens, and Co. at Leeds Pottery* (originally published 1780s) has illustrations of more than seventy ceramic dishes, vases, bowls, tureens, ladles, and other tableware items (fig. 66). From 1770 to 1881, this British firm, located near Leeds, England, manufactured a lightweight, cream-colored glazed earthenware known as "Leeds pottery," featuring plates with lattice-weave patterns, dishes with braided handles, and centerpieces that incorporated figures. The catalog was used to promote Leeds pottery throughout Europe and America.

Around this time, many illustrated historical surveys that detailed the forms and motifs of ancient, medieval, and Renaissance ceramics were being published. These quickly became reference books for collectors and sourcebooks for designers. A notable example is a large folio published as part of a series on sixteenth-century French ceramics entitled *Monographie*

66

Engraving of earthenware
centerpiece. Page 26 from *Designs
of sundry articles of queen's or cream-
colour'd earthen-ware manufactured
by Hartley, Greens, and Co. at Leeds
pottery.* 23 × 29 cm. Leeds, 1780s

67

Hand-colored engraving of
figurative sconce designed by
Bernard Palissy, from *Monographie
de l'oeuvre de Bernard Palissy*, by
Carle Delange (b. 1837). 42 × 54 cm.
Paris: Desaint, 1862

68

Engraving of crystal decanters.
Plate 3 from *Tarifs de la Maison
Launay Hautin & cie seul dépôt des
cristaux des fabriques de Baccarat, St.
Louis, Choisy & Bercy.* 17 × 26 cm.
Paris, 1836

de l'oeuvre de Bernard Palissy (Monograph on the work of Bernard Palissy)
(1862) (fig. 67). Palissy (c. 1510–1590) was a French chemist, glass
painter, and potter who created a multicolored glaze for ceramics called
"terres jaspèes." He is best remembered, however, for his distinctive and
exuberant motifs of molded animals and plants—a style known as "rus-
tiques figulines." *Monographie*, containing a hundred hand-colored
engravings of plates, medallions, candle holders, vases, and other ceramic
objects, includes many colorful examples of molded images of lizards,
birds, shells, fish, leaves, and other nature forms. Palissy's style was
widely imitated in France in the nineteenth century and also adapted by
the famous British ceramics firm Mintons.

Histories, pattern guides, and catalogs that document decorative,
stained, and tableware glass from antiquity to the present are amply rep-
resented in the Library. One of these is a rare nineteenth-century catalog
entitled *Tarifs de la Maison Launay Hautin & cie seul dépôt des cristaux des
fabriques de Baccarat, St. Louis, Choisy & Bercy* (Price lists of the House of
Launay Hautin & Company, exclusive outlet for crystal made by Baccarat,
St. Louis, Choisy & Bercy) (1836) (fig. 68). La Maison Launay Hautin et
Cie, a nineteenth-century Parisian shop that specialized in fine tableware,
regularly issued sales catalogs on glass. *Tarifs* features compote dishes,
goblets, fruit plates, and carafes, all of them offered in a variety of elegant
nineteenth-century crystal patterns created by prominent French design
firms such as Baccarat and St. Louis.

68

One of the most comprehensive tableware catalogs ever produced was issued by Reed & Barton, a large firm known for manufacturing its own sterling and plated tableware and giftware, and established by Henry Gooding Reed and Charles E. Barton in Taunton, Massachusetts, around 1840. This large folio, entitled *Reed & Barton, artistic workers in silver & gold plate* (c. 1884), depicts more than 2,300 gold- and silver-plated items created in the highly ornate styles popular during the Victorian era in America (fig. 69). This catalog gives us a unique view of the fashions, entertaining and dining methods, and ostentatious consumerism of late-nineteenth-century, middle-class Americans. More than forty types of spoon holders, nearly sixty styles of card receivers, more than fifty serving trays or "waiters," and numerous pickle casters, celery holders, and other single-function items are featured. Paging through this book, one can

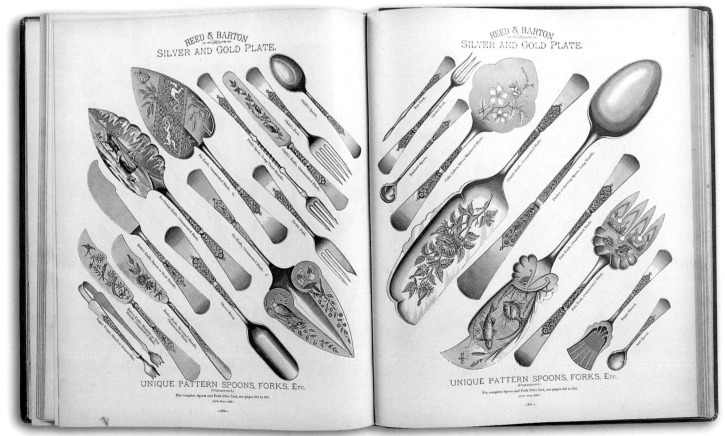

69

Engraving of silver and gold
utensils. Pages 300–301 from *Reed
& Barton, artistic workers in silver &
gold plate*, by Reed & Barton.
37 × 45 cm. Taunton, Mass., c. 1884

Photographs of silver vessels from
Jean Puiforcat, orfèvre-sculpteur.
22 × 29 cm. Paris: Flammarion,
1951

70

readily envision the lavish multicourse dinner parties, complete with
richly decorated place settings and centerpieces, of this gilded age.

In contrast to the ornate styles of Reed & Barton, French silversmith
and sculptor Jean-Elisée Puiforcat (1897–1945) created elegant tableware
and decorative items in simple geometric shapes. Puiforcat studied sculp-
ture, apprenticed as a silversmith with his father Louis, then opened his
own workshop in Paris in 1921. He was influenced by the writings of
mathematician Matila Ghyka (1881–1965) on the golden section—a
system of harmonic proportional ratios devised by the philosopher
Pythagoras (active sixth century B.C.). A survey of his work, *Jean Puiforcat,
orfèvre-sculpteur* (Jean Puiforcat, silversmith-sculptor) (1951), with an
introduction by Paul Léon, and including more than eighty photographs
of silver and metal sculptures, tableware items, and personal and reli-
gious items, provides an excellent overview of his geometric, machine-
like, and streamlined metalwork pieces (fig. 70).

Furnishings and Interiors

The Library contains some of the key resources on the furniture, uphol-
stery, wallcoverings, and interior designs of the past five centuries. One of
the collection's earliest trade catalogs, *The gentleman and cabinet-maker's
director* (1754), by English cabinetmaker Thomas Chippendale (1718–1779),
contains more than 160 engravings of household items he created to pro-
mote his designs (fig. 71). In this work, Chippendale illustrates variant

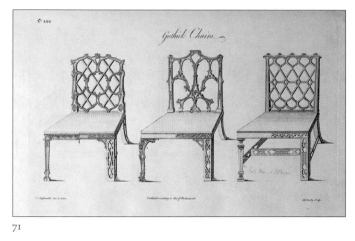
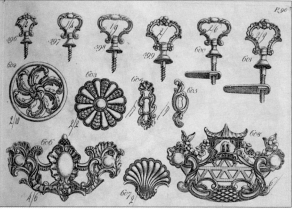

71

72

ornamental motifs (i.e., gothic, Chinese, rococo) and provides perspective drawings of chairs, tables, desks, clocks, pedestals, sideboards, and cabinets. Reissued in 1755, with a revised edition in 1762, *The gentleman* became one of the most widely used pattern books promoting the English rococo, or "Chippendale," style throughout Europe and North America.

Metal manufacturers in the eighteenth century also found the trade catalog to be a valuable way to market their products, especially when new inventions such as the fly press and steam-powered lathe allowed for the mass-production of pressed metal objects such as brass buttons. Much of this manufacturing centered around Birmingham, England, which already had a flourishing cast brass industry. The *Birmingham brass catalogue* (c. 1780), an early example of this type of illustrated sales catalog, contains more than eight hundred brass hardware and decorative objects in a variety of patterns: furniture handles, casters, escutcheons, screws, rosettes, keys, locks, hinges, and brackets (fig. 72). For more than a century, Birmingham brass and metalwork manufacturers continued to issue beautifully illustrated catalogs to sell their products throughout the world.

In the nineteenth century, the latest patterns for textiles, wallcoverings, and furniture were frequently serialized in popular publications (as already noted, in works such as Ackermann's *Repository of arts*). In 1839, Désiré Guilmard (b. 1810), a French furniture designer, began a bimonthly publication entitled *Le garde-meuble* (Furniture repository) (1839–1935) (fig. 73). This journal was intended as a practical visual guide for decorators, architects, cabinetmakers, upholsterers, and all others who designed interiors and furniture. Each issue, depicting designs by

71

Engraving of designs for chairs in the gothic style. Plate 22 from *The gentleman and cabinet-maker's director*, by Thomas Chippendale. 28 × 44 cm. London, 1754

72

Engraving of cast brass hardware and decorative objects. Page 90 from the *Birmingham brass catalogue*. 28 × 18 cm. Birmingham, England, 1780s

73

Hand-colored engraving of corner love seat from *Le garde-meuble*, by Désiré Guilmard. 36 × 26 cm. Paris, 1839–1935

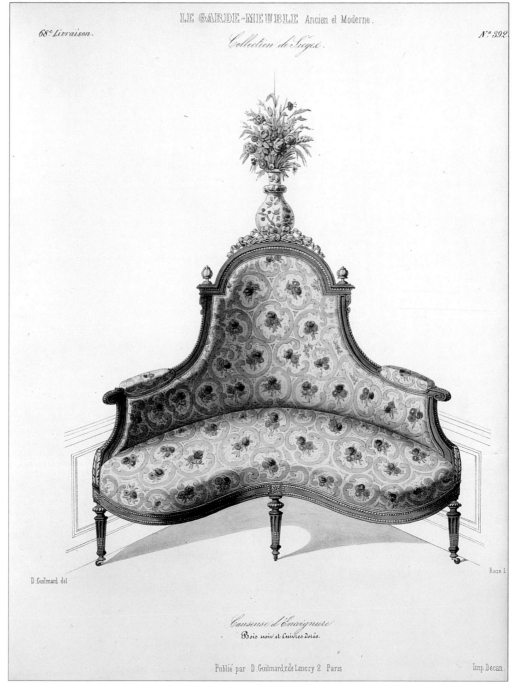

LE GARDE-MEUBLE Ancien et Moderne.

68e Livraison.

Collection de Sièges.

No 392.

D. Guilmard del

Raze L.

Causeuse d'Encoignure
Bois noir et Cuivres dorés.

Publié par D. Guilmard, r de Lancry 2 Paris

Imp. Decan.

73

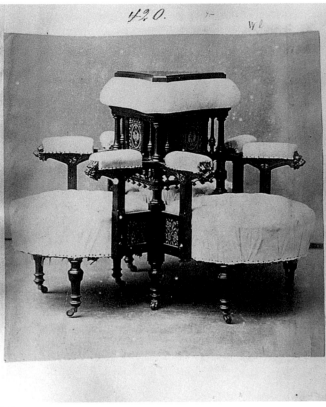

74a

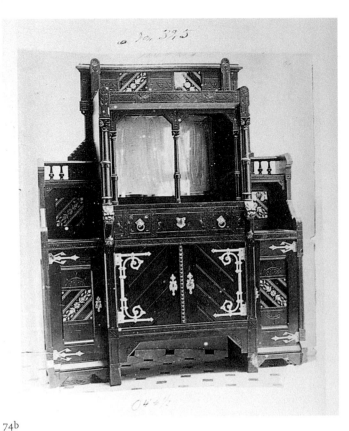

74b

Guilmard and other French firms, consisted of nine plates—three illustrations of seating furniture, three of case furniture, and three of bed and window drapery. Subscribers could purchase all or any part of these three-plate sets in black-and-white or in a hand-colored format. The lithographic images are of a consistently high quality and so detailed that one can detect even small ornamental patterns in the carved cabinetry and motifs on the upholstery. For nearly a century, *Le garde-meuble* chronicled the latest patterns in French furniture, interiors, and fabrics. Today it is a valuable visual resource for both historians and conservators.

Throughout the nineteenth century, American furniture designers continued to be inspired by European trends and patterns, and by publications such as *Le garde-meuble*. At this same time, immigrant European cabinetmakers were bringing with them a variety of new styles, craft skills, and folk traditions. Among them was Anthony Kimbel (d. 1895), a

74a and 74b

Photograph of settée and sideboard from *Furniture designed and sold by the New York firm of Kimbel & Cabus*. 37 × 30 cm. New York, c. 1870s–80s

German cabinetmaker who came to New York in the 1840s and, in the 1850s, was associated with the firm of Bembe & Kimbel. In 1862, he and a New York designer, Joseph Cabus (active nineteenth century) founded the firm of Kimbel & Cabus. Inspired by the writings of British designers Bruce J. Talbert (d. 1881) and Charles Locke Eastlake (1836–1906), the firm developed a line of furniture during the 1870s in the "modern" gothic style. This furniture is characterized by the use of ebonized (blackened or darkly stained) woods ornamented with incised and gilt decoration, inlaid tiles, medieval patterns, and forms that revealed the structure of the piece. A rare trade catalog in the Library's collection entitled *Furniture designed and sold by the New York firm of Kimbel & Cabus* (c. 1875) includes hundreds of household items designed in this neogothic style (figs. 74a, 74b). By the late 1870s, the firm was a leading interpreter of the modern gothic and neo-Renaissance styles used for furniture and interiors in America.

Kimbel & Cabus and other cabinetmakers and decorators frequently consulted books depicting various historic patterns for furniture and interiors that they could copy or adapt. A remarkable example of such a guide is *Diversi maniere d'adornare i cammini: et ogni altra parte deqli edifizj* (Diverse styles of decorating chimney pieces: and all other parts of houses) (1769), by Giovanni Battista Piranesi (1720–1778) (fig. 75). The volume includes more than seventy illustrations of dramatic eclectic designs for fireplaces, mantels, furniture, clocks, and wall panels in the neoclassical style—many of them inspired by Egyptian, Greek, Etruscan, and Roman motifs. Piranesi, an Italian etcher, archaeologist, designer, and architect, produced more than 1,800 illustrations during his career. They featured fantastic views of ancient and contemporary Rome, imaginary prisons, and studies of classical buildings and decorative motifs. His archaeological illustrations of Roman palaces and imaginative interpretations of classical ornament, as seen in *Diversi maniere*, greatly influenced the English designer James Adam. In turn, Adam's designs for chimneypieces and mantels directly inspired the decoration of the interiors at British estates such as Burghley House, Gorhambury House, and Wedderburn Castle.

More than thirty years after Piranesi's book appeared, Thomas Hope (c. 1770–1831), an English collector, designer, and writer, compiled a book on neoclassical furniture and interiors entitled *Household furniture and interior decoration* (1807) (fig. 76). Between 1787 and 1795, Hope had traveled throughout Europe and the Middle East collecting and studying classical artifacts and reading contemporary accounts written about archaeological sites and antiquities. *Household furniture* contains sixty engravings of

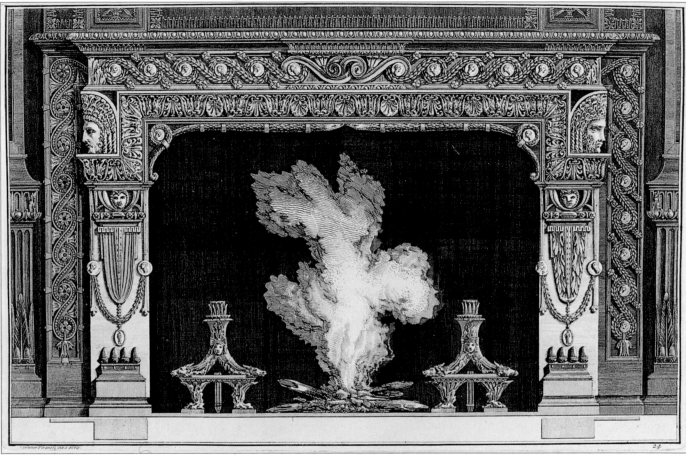

75

Hope's designs for furniture and room interiors that were inspired by the images and writings of, among others, the collaborators James Stuart and Nicholas Revett, Robert Adam, Robert Wood, and Piranesi himself. Like his French counterparts, Charles Percier and Pierre Fontaine (authors of the 1812 *Recueil des décorations intérieures* [Anthology of interior decoration]), Hope promoted the use of neoclassical motifs and forms in room decoration as well as for many household items such as lighting, chairs, sofas, mantels, tables, and ceramic vases. His book exerted a profound influence on early nineteenth-century designers—including English furniture designer George Smith (see chapter 3)—who eagerly copied and adapted his neoclassical patterns.

75

Engraving of a design for a fireplace. Plate 24 from *Diversi maniere d'adornare i cammini*, by Giovanni Battista Piranesi. 45 × 57 cm. Rome: Generoso Salomoni, 1769

76

Engraving of a drawing room in the neoclassical style. Plate 6 from *Household furniture and interior decoration*, by Thomas Hope. 29.5 × 49 cm. London: T. Bensley, 1807

In the early twentieth century, several colorful portfolios containing *pochoir* (silk-screened) prints were published to promote modern interiors and furniture created by the most innovative decorators of the day. Many of these designs either documented or were inspired by the objects exhibited at the 1925 Exposition Internationale des Arts Décoratifs et Industriels Modernes (International Exposition of Decorative Art and Modern Industrial Arts) in Paris. Henry Delacroix (active twentieth century), a French architect and decorator, compiled a beautiful portfolio of *pochoir* prints illustrating more than forty modern domestic interiors entitled, *Décoration moderne dans l'intérieur* (Modern interior design) (c. 1935) (fig. 77). The book, containing designs by Delacroix and several other designers, includes images of streamlined bathrooms, dining areas, studies, living rooms, playrooms, hallways, and bedrooms. Delacroix intended this work to promote contemporary French design and also to provide inspiration for decorators challenged with creating efficient, attractive, and comfortable spaces in modern buildings. It is interesting to note that the Library's copy was originally owned by Donald Deskey, the designer who was instrumental in promoting modern design in America.

In addition to furniture and interior design books, trade catalogs and periodicals that illustrate kitchen and bathroom fixtures, wallcovering

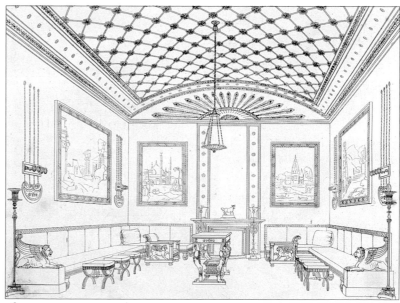

76

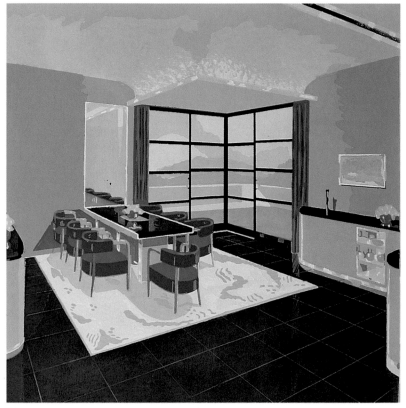

77

77

Pochoir print of a dining room interior from *Décoration moderne dans l'intérieur,* by Henry Delacroix. 34 × 26 cm. Paris: S. de Bonadona, c. 1935

78

Photomechanical reproduction of a color lithograph depicting the "Dolphin" water closet. Plate 125–G–126–G from *Catalogue "G": illustrating the Plumbing and Sanitary Department of the J. L. Mott Iron Works.* 27 × 36 cm. New York, 1888

and molding patterns, lighting, period paint colors, and floor coverings have become essential references for decorators and homeowners involved in renovation projects. The J. L. Mott Iron Works, for example, produced beautiful catalogs on piping, kitchens, fountains and garden furniture, and bathroom fixtures between 1870 and 1907. *Catalogue "G": illustrating the Plumbing and Sanitary Department of the J. L. Mott Iron Works* (1888) contains more than eight hundred lithographs of toilets, urinals, bathtubs, sinks, pipe fittings, shower stalls, and wash basins designed for institutions and residences (fig. 78). The catalog features elaborate and fanciful shapes and patterns popular in the Victorian era, such as polychrome bathtubs with acanthus leaf feet, toilet fixtures in the shape of dolphins, and folding urinals decorated with floral and avian motifs.

Wallcovering trade catalogs, and sample and pattern books are also a rich resource for decorators and historians. Unlike furniture and plumbing

78

companies, most wallcovering manufacturers sold their goods through retail shops and did not use sales catalogs until the late nineteenth century. An early wallcovering sample book entitled *Note pour MM. les presidents et membres du jury international concernant l'etablissement de Jules Desfossé* (Note for their excellencies, the presidents and members of the international jury, concerning the establishment of Jules Desfossé) (1855) (fig. 79), contains twenty-three wallpapers designed by the French firm of Jules Desfossé (d. 1889) that were to be judged at the Exposition Universelle de 1855 in Paris. The firm, later called Desfossé & Karth, was known for high-quality machine-printed papers so richly decorated that they resembled silk, and also for its detailed panoramic landscapes. This 1855 catalog—with its colorful samples and images full of repeat patterns—demonstrates the richness and scope of Desfossé's work as well as the era's styles and taste.

The development of premixed paints in the late nineteenth century

80

prompted the publication of catalogs and books to assist decorators and
homeowners in the exterior and interior use of color for period houses. In
the twentieth century, the changing styles in colors used for interiors were
chronicled in trade and "shelter" magazines and in books on the latest
architectural trends. Bruno Taut (1880–1938), a German architect and writer,
included color charts in his book on house interiors entitled *Ein Wohnhaus*
(One residence) (1927) (fig. 80). Taut, best known for the Glashaus, an
innovative glass pavilion he created in 1914 for the Werkbundausstellung
(arts and crafts guild exhibition) in Cologne, and for his designs for multi-
family housing, wrote extensively about modern architectural materials
and forms. In *Ein Wohnhaus,* Taut sets out the ideal house, in which all
parts (site, circulation, room layout, furniture, lighting, color schemes,
storage systems) are not only functional, efficient, and comfortable, but
work together to create an aesthetically harmonious whole. Numerous
examples of room and garden layouts, built-in cabinetry, color schemes,
and other functional and labor-saving systems amply illustrate Taut's
unifying principle of design. This book, with its emphasis on color,
reveals the early modern movement as richer and more diverse than it is

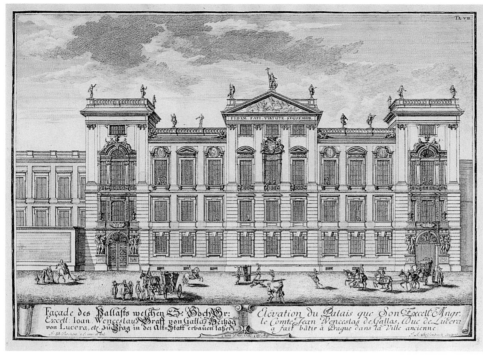

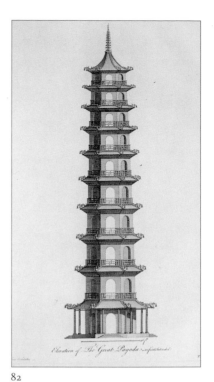

81

82

often characterized. *Ein Wohnhaus* and Taut's earlier book, *Die neue Wohnung* (The new apartment) (1924), document the early functionalist designs of the modern movement that would later inspire architects of the International Style.

Architecture

Many beautifully illustrated catalogs and books have been published that detail the history and design of buildings, cities, and gardens, as well as of industrial design products such as appliances, cars, trains, thermostats, and so on. Like many of the resources reviewed so far, the Library's collection of architecture, landscaping, and industrial design books chronicle the evolution of styles, highlight major innovations, and celebrate the work of a diverse group of talented craftsmen.

One of the most lavish and earliest comparative studies of architecture, *Entwurff einer historischen Architectur* (A plan of civil and historical architecture), by Johann Bernard Fischer von Erlach (1656–1723), features more than ninety illustrated accounts of buildings and cities from around the

81

Engraving of an elevation facade
of a palace in Prague for Count Jean
Wenceslas de Gallas. Plate TA8,
by Johann Adam Delsenbach
(1687–1765) from *Entwurff einer
historischen Architectur*, by Johann
Bernhard Fischer von Erlach.
60 × 43 cm. Leipzig, 1725

82

Engraving of the elevation of the
great pagoda. Plate 23, by T. Miller
(active 1700s), from *Plans,
elevations, sections, and perspective
views of the gardens and buildings at
Kew*, by William Chambers.
40 × 54 cm. London, 1763

world (fig. 81). An Austrian architect and sculptor best known for baroque-style buildings in Salzburg and Vienna, Fischer von Erlach spent more than ten years preparing this work. In it, he promoted his own commissions and recorded sites he visited in Italy and Greece. He also was inspired by other illustrated books, in particular Nieuhof's seventeenth-century travel guide (see chapter 2), which he used as a source for most of his images of Chinese cities and buildings. *Entwurff* is significant for its inclusion of non-European buildings—notably mosques and Chinese bridges—which are given equal status with more traditional neoclassical edifices.

Several years later, English architect William Chambers (1726–1796) also promoted non-Western architectural patterns in his book *Designs of Chinese buildings, furniture, dresses, machines, and utensils* (1757). Based on sketches he made on a 1740s voyage to Canton for the Swedish East India Company, *Designs* contains more than twenty engravings of buildings and furniture that could easily be copied or adapted by designers. One lover of chinoiserie and a supporter of Chambers was Augusta, Dowager Princess of Wales. In 1757, she encouraged the royal family to commission him to remodel the extensive gardens at Kew. For the next six years, Chambers worked on this project, developing an overall plan for the garden as well as plans for an aviary, greenhouses, a great pagoda, a theater, and several pavilions in a number of eclectic styles. When the commission was completed, King George III financed the publication of a beautiful folio containing more than forty of Chamber's designs entitled *Plans, elevations, sections, and perspective views of the gardens and buildings at Kew* (1763) (fig. 82). Besides the gardens and structures at Kew, *Plans* also contains Chamber's detailed drawings of buildings in gothic, Chinese, neoclassical, and Islamic styles.

Books illustrating the designs of English architects such as Chambers, James Gibbs, Inigo Jones, among others, were frequently copied or adapted by builders in the United States. As both the American population and economy continued to grow in the nineteenth century, so did the demand for new housing, churches, and educational, commercial, and industrial buildings. Local designers, such as Philadelphia architect John Riddell (1814–c. 1871), began publishing pattern books on the latest building designs in the hope of attracting clients. Riddell's *Architectural designs for model country residences* (1861), contains chromolithographic elevations and floor plans drawn at 1/4-inch scale, accompanied by general descriptions and building cost estimates for twenty country houses, most in the Italianate style (fig. 83). This handsome catalog, featuring a variety of pale

Villa Nº 9

John Riddell, Architect. SCALE ¼ in = 1 foot. FRONT ELEVATION. 36 ft. front ... lith. Phil.ᵃ

83

Plans for Villa, N° 9.

WASH HOUSE
13' 6" × 11' 6"

RANGE

KITCHEN
14 × 15'

PORCH

STORE ROOM
5' 6" × 4' 6"

CLOSET

PASSAGE

DINING ROOM
14 × 23' 6"

PARLOR
14 × 20'

HALL
7'

38 FT.

PORCH.

FIRST STORY.

ROOF

NURSERY
14 × 12'

PASSAGE

ROOF

BATH ROOM
4' 6" × 3' 6"

B TUB

CHAMBER
14 × 13' 9"

CHAMBER
10 × 9'

PASSAGE

CLOSET

CLOSET

CHAMBER
16' 6" × 14' 6"

CHAMBER
19 × 14' 6"

7 × 2' 6"

ROOF

SECOND STORY.

SCALE—8 ft. to an Inch.

John Riddell, Architect.

T. Sinclair's lith, Phila⁴ˢ

84

tints for exterior walls, with contrasting hues for trims, shutters, and other architectural details, is the best surviving guide to the era's taste in paint coloring.

A number of books featuring architectural projects that had been included in, or had won, competitions were also published during this time. At the turn of the century, Mackay Hugh Baillie-Scott (1865–1945), a Scottish architect, won a commission over designers Charles Rennie Mackintosh and Hermman Muthesius to do a country house for the Duke of Hesse in Darmstadt. His designs for this commission are recorded in a colorful folio entitled *Baillie Scott, London: haus eines Kunst-freundes* (Baillie Scott, London: house for an art lover) (c. 1902) (fig. 84). Containing ten elevations, floor plans, architectural details, and interior views, the book illustrates elements of Baillie-Scott's style—a simpler and more refined version of earlier arts and crafts designs of William Morris and C. F. A. Voysey, in which buildings are well suited to the site and have brightly colored interiors. This folio also includes Baillie-Scott's open

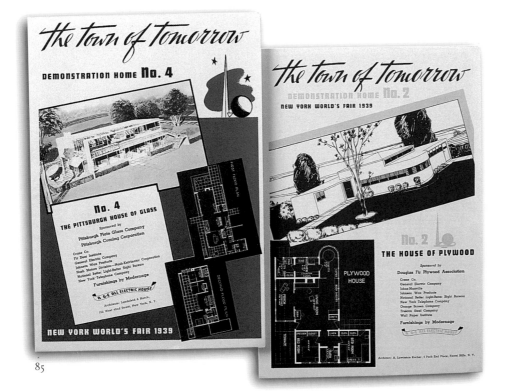

85

Photomechanical reproduction of
color pamphlets for the
Demonstration House no. 2
(The House of Plywood) and
Demonstration House no. 4
(The Pittsburgh House of Glass) for
The Town of Tomorrow exhibition at
the 1939 New York World's Fair,
from *The town of tomorrow*.
22.5 × 30 cm. New York, 1939

planning scheme, in which interior spaces are designed to be multi-functional—an idea that later appeared in the work of architects Josef Hoffmann, Peter Behrens, Frank Lloyd Wright, and others.

In the twentieth century, architects continued to experiment with interior space planning schemes as well as new structural systems and building materials that would make homes more functional, affordable, and easier to construct. *The Town of Tomorrow*, an exhibition at the New York World's Fair (1939–40), explored this theme of the modern house with a display of fifteen model residences designed for an Atlantic coast climate. The models, with names such as "The bride's home," "House of plywood," "All-gas home," "The Celotex house," "New England home," and "Motor home," were constructed of diverse materials, had a variety of energy systems, and ranged in price from $3,000 to $35,000 (the median price for a house was then about $6,500). Though varying in style from colonial revival to streamlined modern, each model promoted the idea that future dwellings would be safe, energy efficient, easy to maintain, and contain

86a

86a and 86b

Hand-colored engraving of "before" and "after" views of the water and landscape depicting Wentworth House, Yorkshire. Page 40 from *Observations on the theory and practice of landscape gardening*, by Humphry Repton. 29 × 35 cm. London: T. Bensley, 1803

86b

labor-saving devices. A souvenir folder entitled *The town of tomorrow and the home building center* (1939), which includes brochures with information about and plans and renderings for each house, attests to the emerging technologies, varied architectural styles, and taste of the time (fig. 85).

Landscape, Theater Set, and Industrial Design
Like the *Town of Tomorrow* brochures, *Observations on the theory and practice of landscape gardening* (1803), a colorful garden planning book, provides a large and varied selection of designs (figs. 86a, 86b). The author, Humphry Repton (1752–1818), a leading English landscape designer and writer, compiled a series of portfolios known as the "red books" (the original set was bound in red leather) in which he recorded design ideas and past commissions. *Observations* includes Repton's theories on the creation of landscaping that was picturesque yet also practical, together with references to more than one hundred past commissions selected from his red books. In this work and in the red books, Repton used a hinged flap superimposed on an illustration that, when closed, depicted an unimproved site and, when open, revealed the transformed garden or landscape. The book is a fine example of a garden-design manual rich with detailed plans for landscape projects which, at the same time, also functions as an early and unique trade catalog that its designer used to promote his career.

Repton's designs in the *Observations* demonstrate his talent to transform and manipulate landscape spaces. In a similar way, Italian designer Giuseppe Galli Bibiena (1696–1757) used intricate systems of perspective to create dramatic illusionary theater sets and festival decorations for the royal families of Austria and Germany. Galli Bibiena apprenticed with his father Ferdinando, who experimented with lavish architectural opera and stage scenery that created the illusion of endless vistas. Guiseppe continued his father's work, designing even more sumptuous sets for Charles VI of Austria. A book of his designs, entitled *Architetture, e prospettive* (Architecture, and perspective) (1740) (fig. 87), contains more than fifty engravings of baroque and neoclassical altars, palace interiors, monuments, and theater sets—many of them created for religious festivals in Vienna in the chapel at Hofburg, the imperial palace of (in succession) the Holy Roman, Austrian, and Austro-Hungarian empires. Galli Bibiena's work, which documents the ostentatious styles and tastes of the period, continues to amaze and inspire designers even today.

Personal narratives play an important part in revealing the designer's

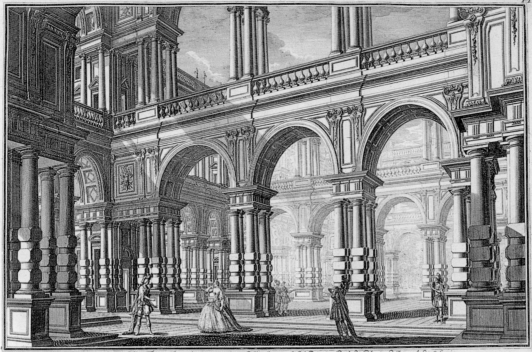

Scena della Festa Teatrale in occasione delli Sponsali del Principe Reale di Polonia ed Elettorale di Sassonia

87

philosophy and intent as well as the processes employed in the creation of his vision. In the twentieth century, a number of industrial designers, including Raymond Loewy, Norman Bel Geddes, Walter Dorwin Teague, and Henry Dreyfuss, wrote treatises outlining the major precepts of their then-emerging profession. Walter Dorwin Teague, Sr. (1883–1960) and engineer Howard C. Marmon (active twentieth century) collaborated on the development of an automobile called the Marmon 16 and then published a two-volume account of their experiences, entitled *The Marmon Sixteen* (c. 1930) (fig. 88). Teague worked with his son, W. Dorwin Teague, Jr. (b. 1910), who was the principal designer for both the Marmon 12 and Marmon 16 cars. The elder Teague explains in this book how the unique streamlined contours not only make the car attractive but more energy efficient and roomier as well. Though the car was in production only a limited time, the book remains as an early testament of the designer's evolving importance in the development of automobiles and appliances in the twentieth century.

88

87

Engraving of a theater set created in
celebration of a wedding for the
Prince of Poland. Plate 7, part 1, by
Lorenzo Zucchi (1704–1779) from
Architetture, e prospettive, by
Giuseppe Galli Bibiena. 40 × 60 cm.
Augusta [Augsburg], 1740

88

Cover from the volume entitled
"from the notes of the engineer," by
Howard C. Marmon and photograph
of the Marmon Sixteen from the
volume entitled "from the notes of
the designer," by Walter Dorwin
Teague, Sr., from *The Marmon
Sixteen*. 12 × 17 cm. Indianapolis,
c. 1930

Through the diverse resources examined here—which deal with differ-
ent cultures, aesthetic movements, periods, and objects—similarities in
the design process can be identified and, in some cases, even how one
style may have inspired the emergence of another can be discerned. Trade
catalogs, ranging from small pamphlets to oversized presentation portfo-
lios, also document period styles by presenting us with a select group of
items considered important in a particular era and society. Together with
the illustrated historical surveys, journals, and personal narratives also
included in this chapter, they comprise some of the key works on trends,
personalities, events, and philosophies affecting the history of design and
the production of objects over the past several centuries.

ERUPTIVE PROMINENCE June 4, 1946
Photo by Walter Orr Roberts
High Altitude Observatory, Climax

White dot indicates size of Earth

GROUP OF SUNSPOTS April 7, 1947
Photo Mt. Wilson and Palomar Observatories

SUN DATA The Sun is a star of generous but not unusual proportions. Like other stars, and unlike most non-luminous astronomical bodies, it is gaseous throughout its gaseous interior, by virtue of its massive size, temperature and crushing gravitational forces, is wholly opaque. Boundary of interior, known as Photosphere, is as sharp as though made of stone. Surrounding opaque sphere is mysterious solar atmosphere—visible to the naked eye only during brief moments of total solar eclipse—made up of tenuous and luminous Corona, jagged flame-like Prominences and narrow color fringe of Chromosphere.

PROMINENCES—giant clouds of hydrogen and other gases are irregularly scattered over Sun's surface. They look like great tongues of brilliant red flame reaching sometimes tens or even hundreds of thousands of miles above Sun's surface. They travel as though directed by magnetic forces known to exist in Sun. Their speeds reach many hundreds of miles per second.

SUNSPOTS Cooler places in the Sun are sunspots, relatively small areas whose temperature may, for instance, sometimes drop to a mere 7,000°F. Sunspots appear periodically, rising and falling in number, in cycles of about a decade. They are symptoms of solar disturbances. When most numerous, electrical and magnetic conditions of earth's upper atmosphere respond with disturbances which affect, among other things, radio communications.

CHROMOSPHERE Directly above luminous Photosphere surface, from which Sun radiates main supply of energy, lies brilliant Chromosphere, a narrow layer of radiant gas completely enveloping Sun. It glows for a few seconds at start and end of total eclipse as a brilliant red fringe or intense dark ledge.

RADIUS OF SUN 432,000 MILES

CORONA, seen brilliantly during eclipse, concealed by sunlight at other times, hides numerous scientific riddles in its pale white glow. It contains atoms of high temperature and low pressure utterly unattainable on earth. It consists in part of electrons speeding thousands of miles per second. Wholly successful explanation of Corona's behavior eludes even most advanced efforts of astrophysics. Corona changes from day to day in synchronism with solar riddles yet unknown. Diffuse rings from interference with radar reception to faintly fluxuating aurorae over polar regions of earth.

ENERGY SOURCE Exact process by which Sun's vast store of energy is released still eludes astrophysicists. Fuel, however, is hydrogen, most abundant element of Sun. Deep beneath the surface exist enormous temperatures as high as 30,000,000°F. Pressures reach many millions of tons per square inch. There in the vast atomic desert hydrogen atoms fuse together to form helium—a process which releases energy that lights solar system. According to best estimates, hydrogen of Sun is sufficient to provide sunlight at present rate for the next 10 billion years.

Chapter Five

The Art and Enjoyment of the Book

In addition to appreciating the content of printed illustrated books, it is equally gratifying to admire them as works of art. They incorporate a variety of lettering styles, decorative borders, endpapers, illustrations, and covers that are integral to their beauty and, ultimately, to the reader's enjoyment of them. This chapter examines some finely crafted items from the collection—pop-up books, limited editions, typography guides and innovative layouts, and decorative bindings and covers—as "designed objects."

Pop-Up Books

In the nineteenth century, a number of juvenile books were published to both educate and entertain children. Many had moveable parts and pop-up images that literally brought a new dimension to traditional fables, nursery rhymes, and children's stories. An early inventor of this type of book was Lothar Meggendorfer (1847–1925), a German writer, genre painter, and illustrator. In the 1880s, he developed simple pull-tab lever systems for his children's stories to create images with moveable parts. A wonderful example of his early work, entitled *Neue lebende Bilder: ein Ziehbilderbuch* (New living pictures: a pop-up book) (1880s), consists of eight whimsical scenes of people performing everyday tasks—women washing clothes, a man sawing wood, an artist painting—each with pull tabs and hinges that permit the figures to move (figs. 89a, 89b).

In the United States, many pop-up books published in the 1930s recreated popular classics such as Cinderella and Pinocchio, and comic strips such as Dick Tracy, Tarzan, and Little Orphan Annie. One title is the colorful *Buck Rogers, 25th century featuring Buddy and Allura* (c. 1935), illustrated by Dick Calkins (1895–1962) and written by Philip Nowlan (1888–1940) (fig. 90). The book features an episode from the popular daily comic strip

Opposite

Detail of figure 95

in which twenty-fifth-century space adventurer Buck Rogers and his friends Buddy and Allura battle insectlike space aliens who have invaded the planet. Three dramatic pop-ups are included in this volume.

Limited Editions

For adults, beautifully crafted and decorated limited editions explore the form of the book and its overall layout and design. Memorable ones were created in the second half of the nineteenth century by artists of the arts and crafts movement in England and America. The movement promoted high-quality, hand-crafted printed books over the mass-produced ones made possible by the industrial revolution; it was particularly inspired by the motifs, layouts, and typography of medieval manuscripts and early printed books. William Morris (1834–1896), an English designer, writer, and a leader of the arts and crafts movement, had a special interest in publishing such limited editions. To create this type of book, he believed that all of its

89a

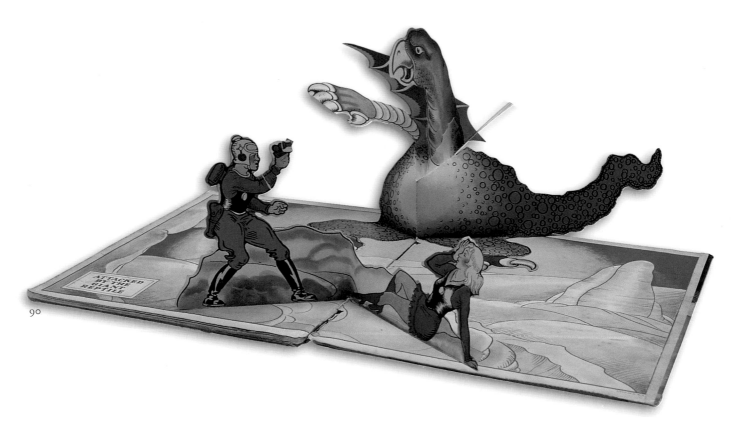

90

89b

89a and 89b

A hand-colored lithograph of a moveable image depicting a man and dog from *Neue lebende Bilder: ein Ziehbilderbuch,* by Lothar Meggendorfer. 23.5 × 33 cm. Munich: Braun & Schneider, 1880s

90

Photomechanical reproduction of a pop-up construction entitled "Attacked by the Giant Reptile," illustrated by Dick Calkins, from *Buck Rogers, 25th century featuring Buddy and Allura,* by Philip Nowlan. 20 × 24 cm. Chicago: Pleasure Books, Inc., c. 1935

91

Engravings of the opening spread of Chapter 1, illustrated by Edward Burne-Jones, from *The wood beyond the world,* by William Morris. 15 × 22 cm. Hammersmith, England: Kelmscott Press, 1894

91

basic elements—paper, ink, ornament, typography, and binding—had to be designed as a unified whole. Morris established the Kelmscott Press, which published fifty-three of these titles between 1891 and 1898. *The wood beyond the world* (1894), a mythical tale written by Morris and illustrated by his friend, the English painter Edward Burne-Jones (1833–1898), is one fine example (fig. 91). The vellum binding, ornamented borders and colophons, distinctive typography and wide margins, and even the texture of the paper, all contribute to the rich, hand-crafted appearance of the work.

A generation later, teacher-designer Hendrik T. Wijdeveld (1885–1989) founded the monthly periodical *Wendingen: maanblad voor bouwen en sieren* (Turning directions: monthly magazine for building and embellishing) (1918–31) to primarily promote the work of a group of Dutch Expressionist craftsmen and architects known as the Amsterdam School (figs. 92a, 92b). Its dramatic, large-format covers (each created by a different artist), hand-crafted string bindings, distinctive layout and lettering styles, and abundance of illustrations make every issue a work of art. Each one consists only of a photo essay and commentary on a single topic. The topics ranged from Japanese sculpture and contemporary bookplate patterns to the latest projects of H. P. Berlage, Michel de Klerk, and other Amsterdam School architects. *Wendingen* is significant as a document of important art, graphic, and architecture subjects of the post–World War I period.

92a

92b

Typography Guides and Innovative Layouts

Around this time, Frederic Goudy (1865–1947), an American printer, graphic designer, and typographer, inspired by the Kelmscott Press, established a printing shop in 1895 called Booklet Press (later Camelot), where he experimented with type design in limited editions. After Goudy published more than eleven titles and created his first typeface, also called Camelot, he traveled to Europe in 1909 to study historic and contemporary lettering. On his return, he spent the rest of his career teaching and writing on typography and designing more than 120 typefaces. One of his first illustrated manuals on type design, entitled *The alphabet* (first published 1918), includes fifteen "interpretative" designs for select letters (fig. 93). In *The alphabet* and in a later companion volume entitled the *Elements of lettering* (1922), Goudy includes chapters in each book on the origin and history of letter design along with more than four hundred examples of typefaces for the use of designers and students.

Advances in technical processes coupled with the growth of the packaging, advertising, and publishing industries, spearheaded the production of innovative graphics in the twentieth century and, indeed, gave rise to graphic design as a profession. The book cover (and sometimes the entire volume) became a medium for promoting modern typefaces, as well as the latest avant-garde graphic designs of the dada, surrealist, cubist, Bauhaus, and constructivist art movements. Many book covers inspired by these art movements appeared in Germany and Czechoslovakia in the era between the world wars. Ladislav Sutnar (1897–1969), a Czech graphic and industrial designer (see chapter 3), created the cover and typography for a compendium of essays and drawings on the planning of

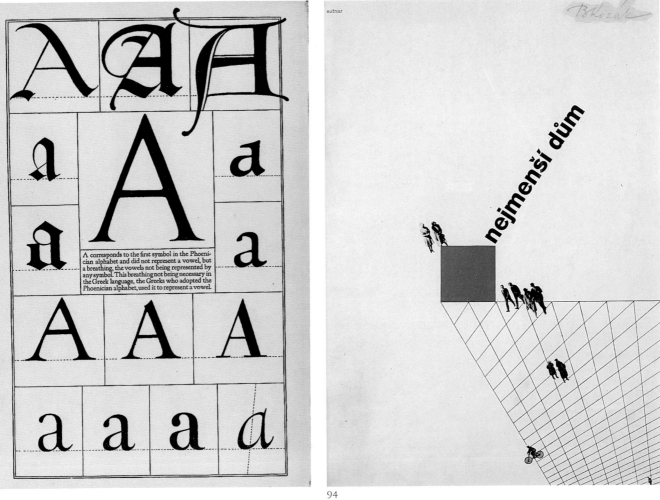

small row houses entitled *Nejmenši dům* (The smallest house) (1931) (fig. 94). Sutnar develops an interesting visual analogy between the book's theme, creating innovative and functional spaces for the masses, and the book's cover design, which superimposes figures around a cube and grid. The drama is heightened by the bold typography of the title, which emanates on a diagonal slant from a distinctive orange block. Also on the cover are randomly placed surreal photomontage images.

Sutnar emigrated to the United States in the late 1930s, as did a number of other European artists and architects, each bringing a variety

95

of modern design styles and theories to America. Among them was the Austrian painter, designer, typographer, and photographer Herbert Bayer (1900–1985), who studied, and later taught, at the Bauhaus in Dessau, Germany, in the 1920s. In America, Bayer worked as a commercial artist in New York with clients such as John Wanamaker and J. Walter Thompson. His paintings were exhibited at a one-man show at Black Mountain College in North Carolina in 1939, and on several occasions between 1938 and 1943 at the Museum of Modern Art in New York. In 1946, Bayer became a designer for the Container Corporation of America (CCA) in Chicago and, in collaboration with CCA's founder and chairman, Walter Paepcke, he spent five years planning and editing a remarkable volume entitled the *World geo-graphic atlas* (1953) to celebrate the firm's twenty-fifth anniversary (fig. 95).

Bayer's goal was to create not only an easy-to-use atlas for the general reader, but one that also encompassed, in an understandable way, the natural and human activities of the entire planet. This amazing reference tool, with more than 120 colorful maps and 1,200 charts and diagrams, successfully presents a considerable amount of complex information on diverse topics—ranging from air travel routes to agricultural production in Puerto Rico—in an easy-to-access and visually appealing manner. Bayer used numerous overlays, more than 4,000 pieces of art, a variety of typefaces, spacious margins, and eight to ten colors on many of the plates. The *World geo-graphic atlas* set the standard for later atlases because it demonstrated how, through creative layout and innovative artwork, a wide variety of scientific and statistical data could be incorporated into a single volume that was attractive as well as informative.

Decorative Bindings and Covers

In addition to a book's overall design, other elements such as slipcases, decorative endpapers, and elaborate bindings were created to embellish and encase volumes their owners deemed special. A variety of materials were employed for this purpose, most commonly vellum (calf, kid, or lamb skin) and leather, but also more exotic ones such as embroidered fabric, ivory, papier-maché, wood, enamel, stainless steel, and precious metals. A rare silver binding encases Martin von Cochem's (c. 1634–1712) German prayer book entitled, *Antoni-Büchlein, oder, Andächtiges Geist—und*

96

97

Trostreiches Gebett-Büchlein (Small Antoni book, or, devoutly spiritual and consoling prayerbook) (1675) (fig. 96). This ornate binding, depicting the Annunciation (front), the Visitation (rear), and floral patterns (spine) is a remarkable example of repoussé, or "raised," silverwork. It has been suggested that such highly decorated liturgical items produced at this time were a response by the Catholic Church to the simplicity advocated by the emerging Calvinist Protestant sects.

Western book design followed its own conventions for centuries, however. But with the opening of trade with Japan effected by Commodore Matthew C. Perry (1794–1858) in 1854, and with the exhibition of Japanese artifacts at the 1862 fair in London, Westerners began to have greater access to the very different styles, colors, and motifs of this culture. George Ashdown Audsley (1838–1925), a Scottish architect, designer, and ornamentalist, wrote several books promoting Japanese culture and art. Among his publications was a paper he presented at the Architectural Association in London in 1872, entitled *Notes on Japanese art* (1872),

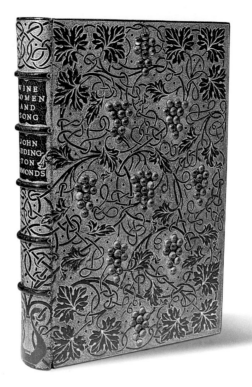

98

which includes some of the earliest photographs of Japanese ceramics and lacquerware (fig. 97). J. Leighton (active nineteenth century), a London bookbinder, and Audsley had turned this essay into a book by enclosing it and its illustrations within decorated endpapers and providing it with leather inlay covers that had gilded floral medallions and abstract motifs inspired by Japanese ceramic patterns. The glossiness of the distinctive gold and red symbols on a black background on the endpapers gives the work a lacquerlike quality.

A number of elegant, tooled-leather bindings created toward the end of the nineteenth century followed in the tradition of handcraft work established by the arts and crafts movement. The London bindery firm of Sangorski and Sutcliffe produced some of the most lavish covers, including that for John Addington Symonds's *Wine, women, and song; mediaeval Latin students' songs now first translated into English verse* (1884) (fig. 98). This volume contains selections from *Carmina burana* (The songs of Beuren), a group of thirteenth-century secular Latin songs uncovered in a German monastery

in 1803. The magnificent covers and spine, consisting of tooled and gilded green Moroccan leather with (on the front and back covers) grape clusters made of amethysts, depict an intricate curving grape vine and its leaves, an image that thematically relates to the volume's verses. The dramatic curvilinear patterns, characteristic of the art nouveau style, are continued on the book's separately styled and tooled leather endpapers.

Today, contemporary graphic designers and book artists continue to use and refine these same elements—pop-ups and moveable mechanisms; ornamented covers, endpapers, and borders; and innovative layouts and typography—to transform books from mere information resources into works of great design. Such limited editions are a superb medium for displaying and promoting creative graphic and paper construction techniques throughout the world. The Library's collection continues to serve artists and designers both as a historical reference and as an ongoing source of inspiration.

The titles in this book represent only a few of the multitude of beautifully designed and printed books that provide seemingly endless information on the patterns, the environments and events of past eras, materials and manufacturing techniques; and major titles that document design and the decorative arts. These timeless sources provide a rich and unique insight into design movements, the history of illustration and printing processes, as well as the evolution of the book as a designed object during the past five centuries. They reveal to us the very foundations of design and, at the same time, continue to amaze, instruct, and above all, delight.